HOME ALONe

THE AUTHORIZED COLORING BOOK

ILLUSTRATED BY ALEX FINE

HARPER
DESIGN

An Imprint of HarperCollinsPublishers

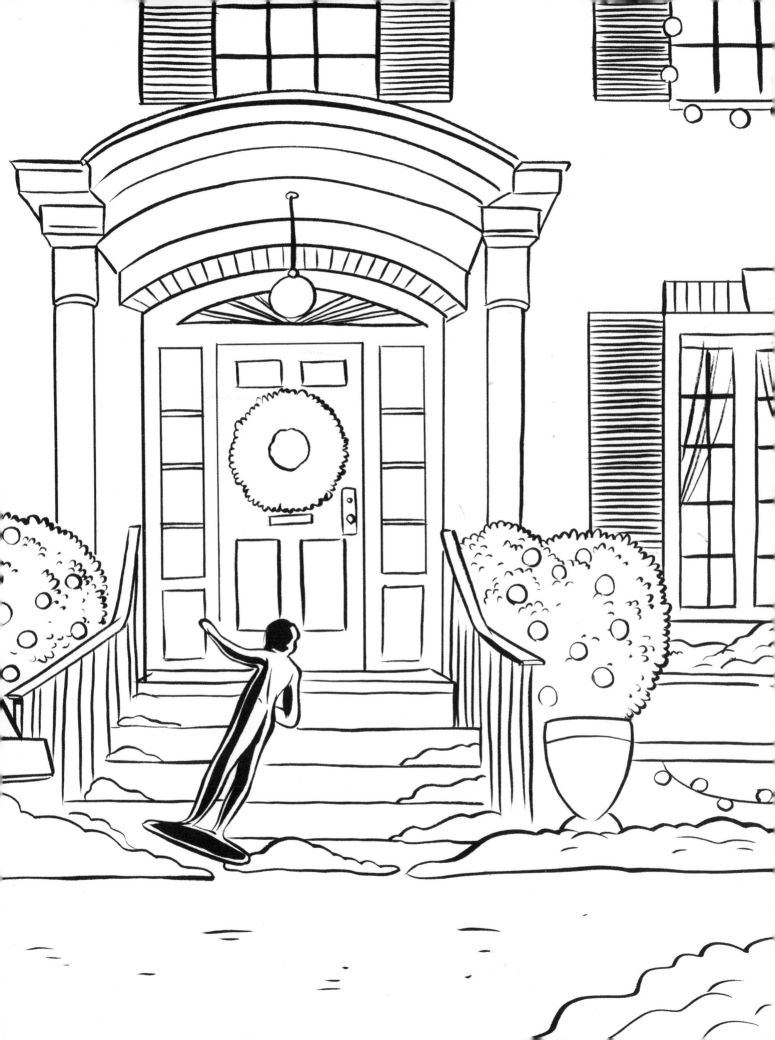

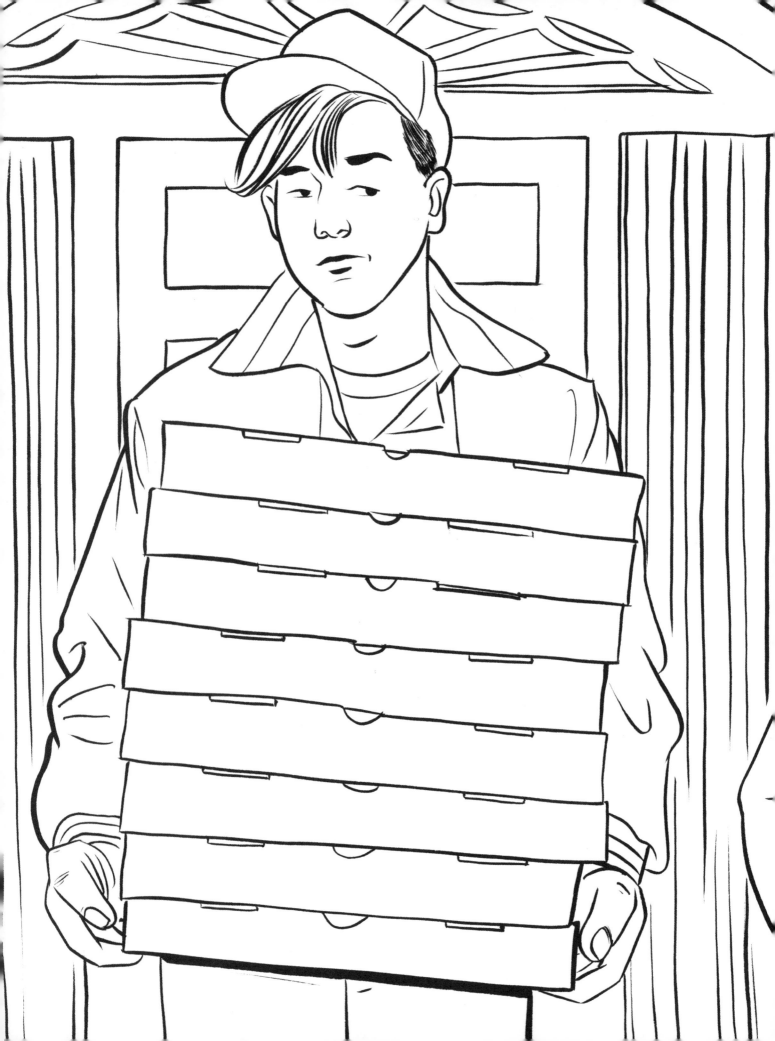

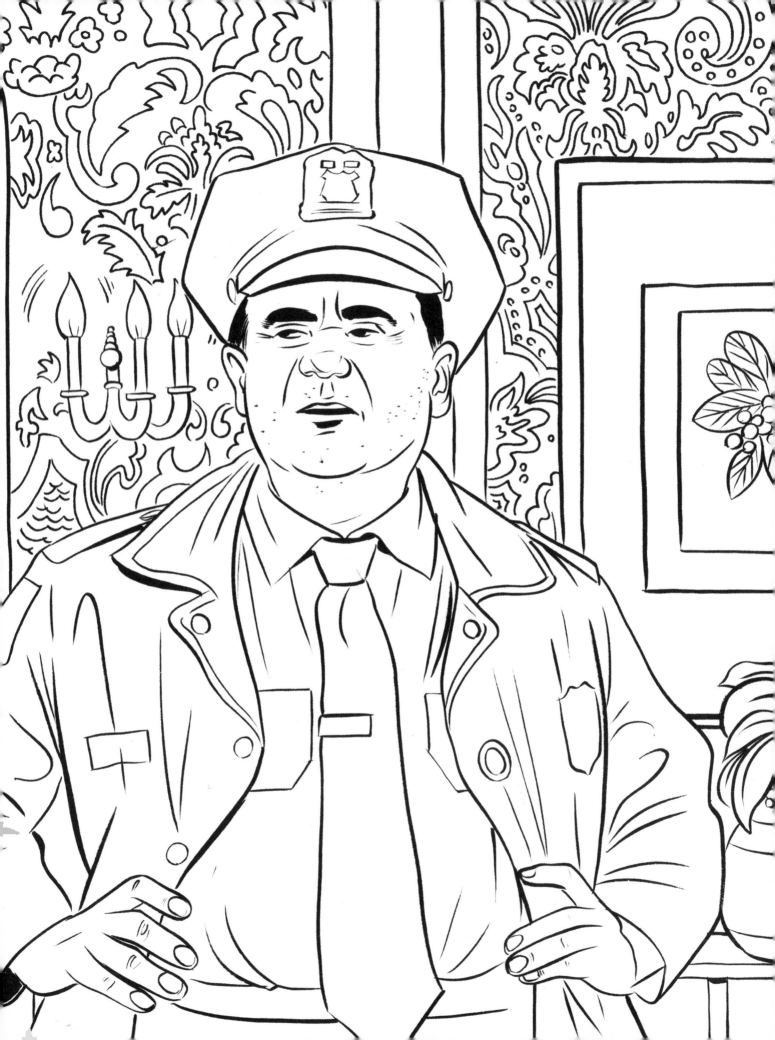

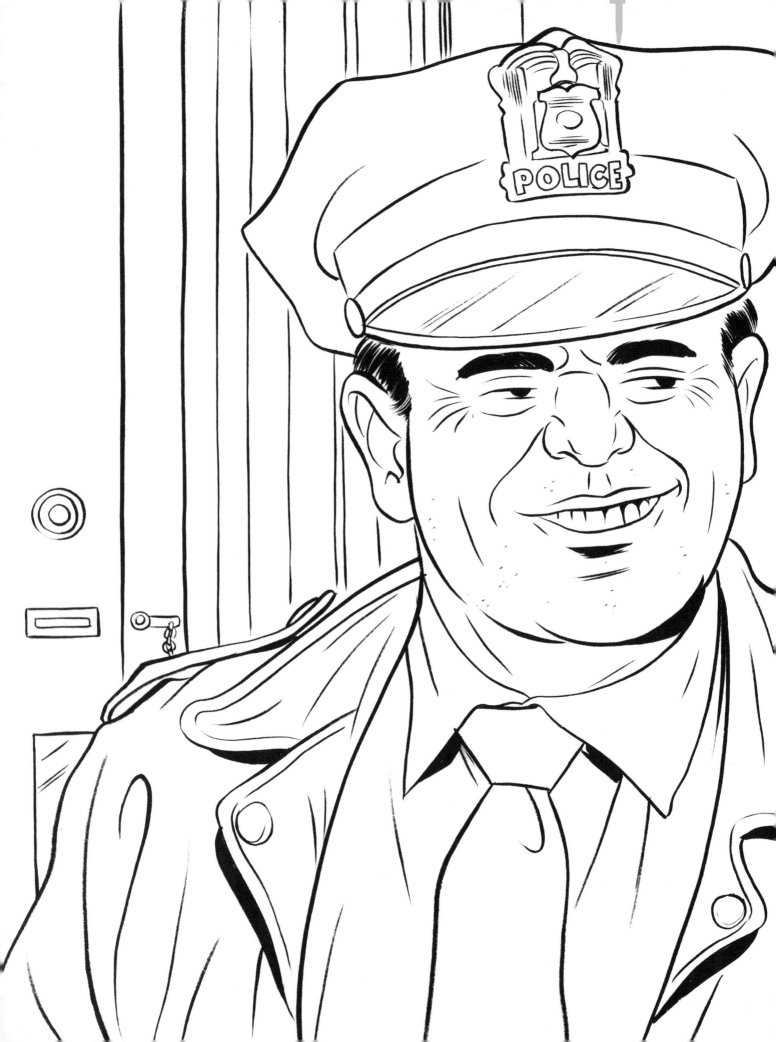

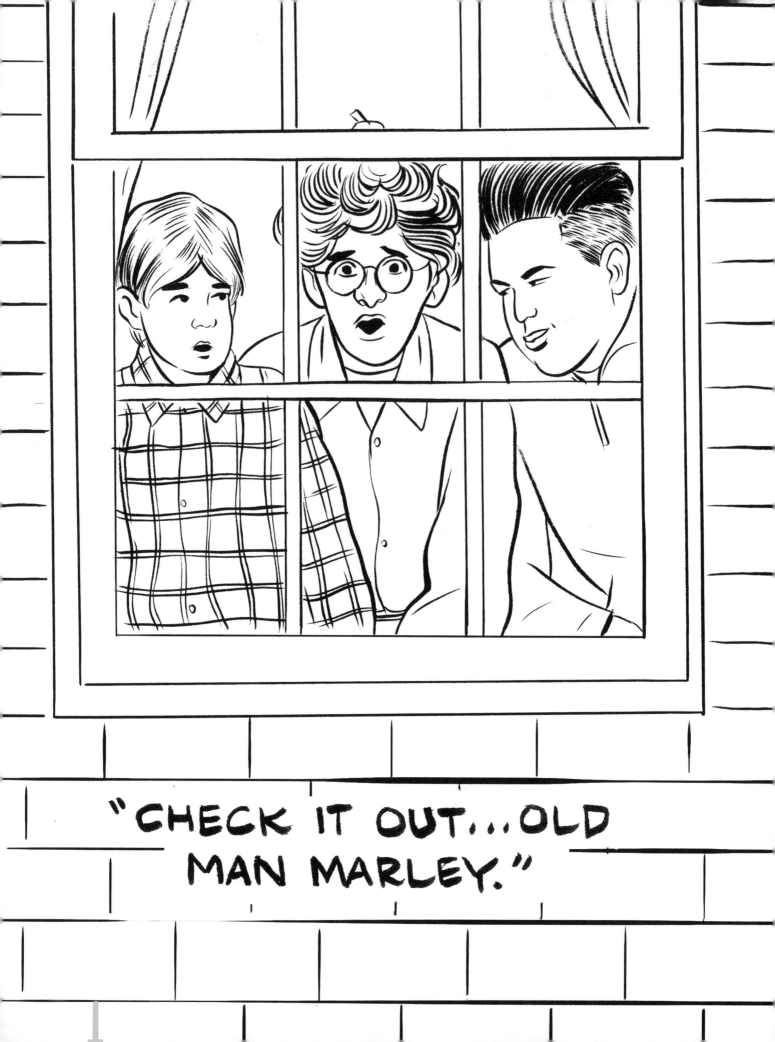

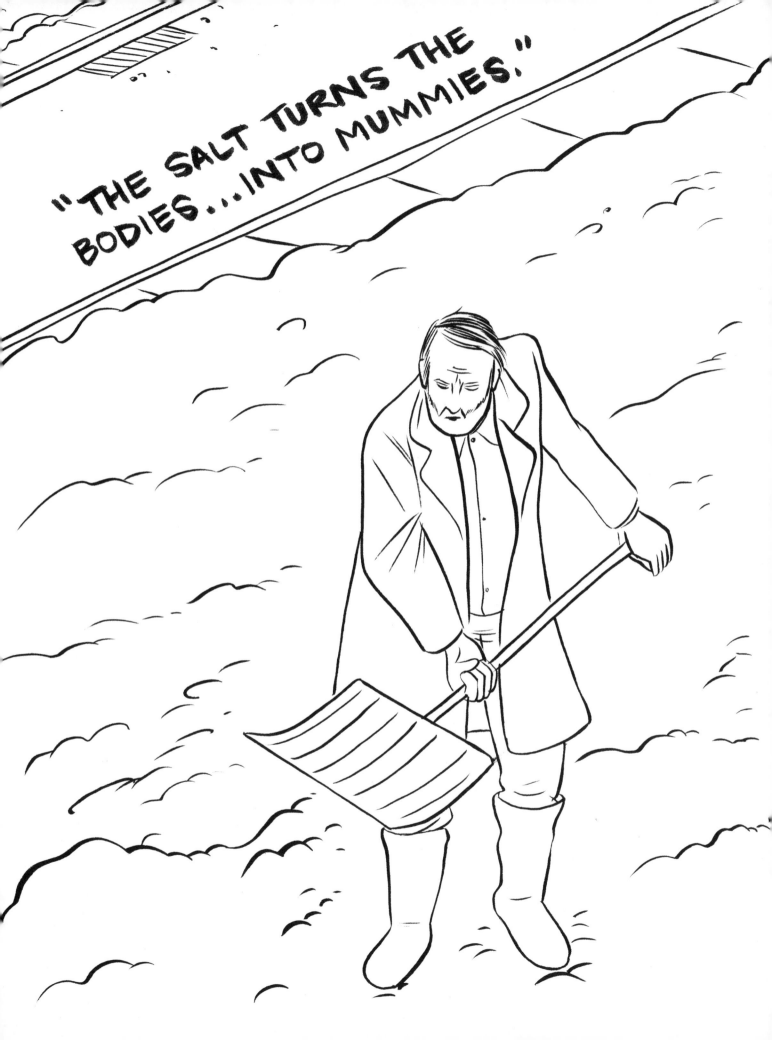

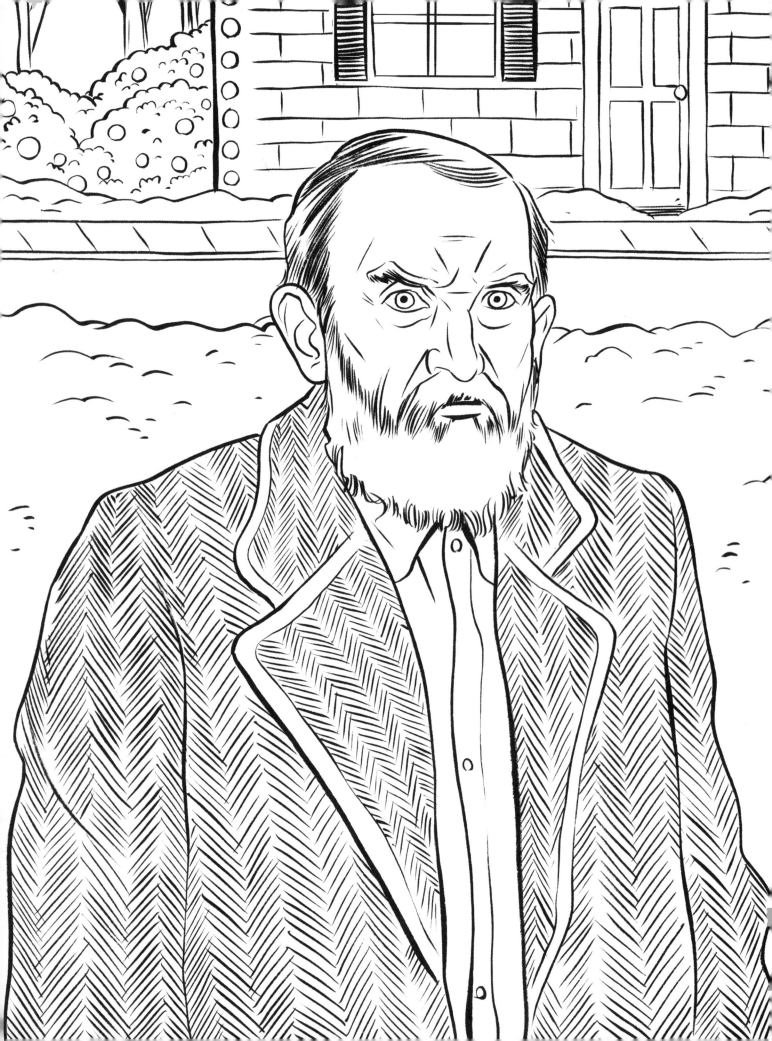

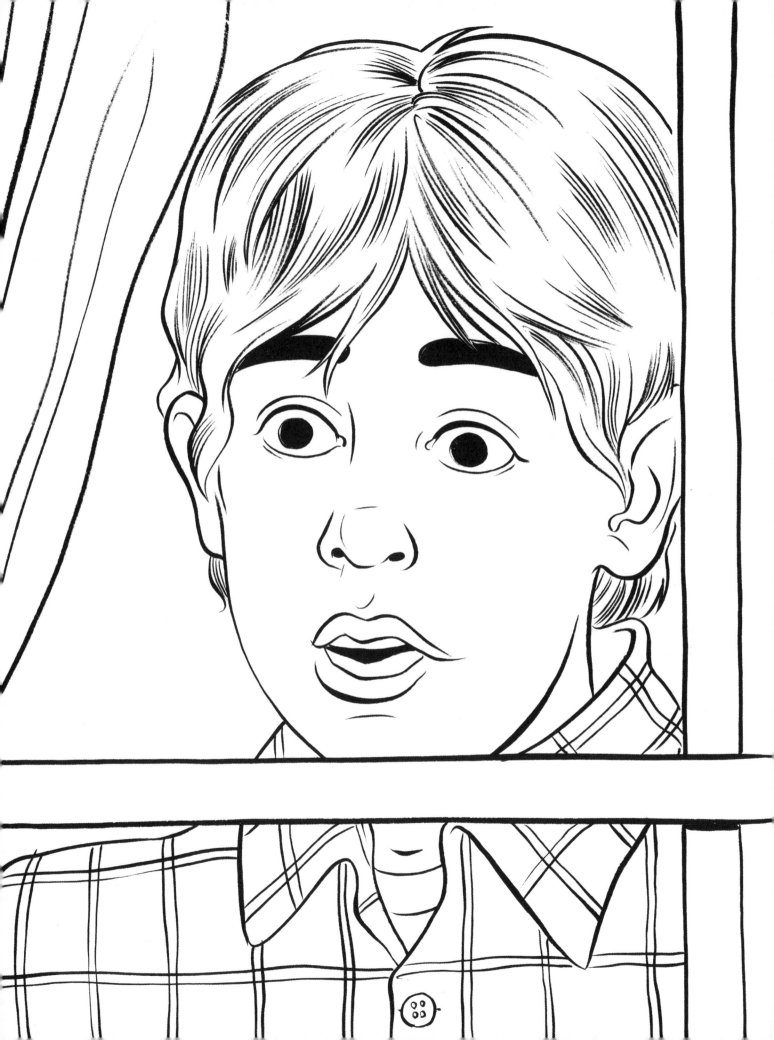

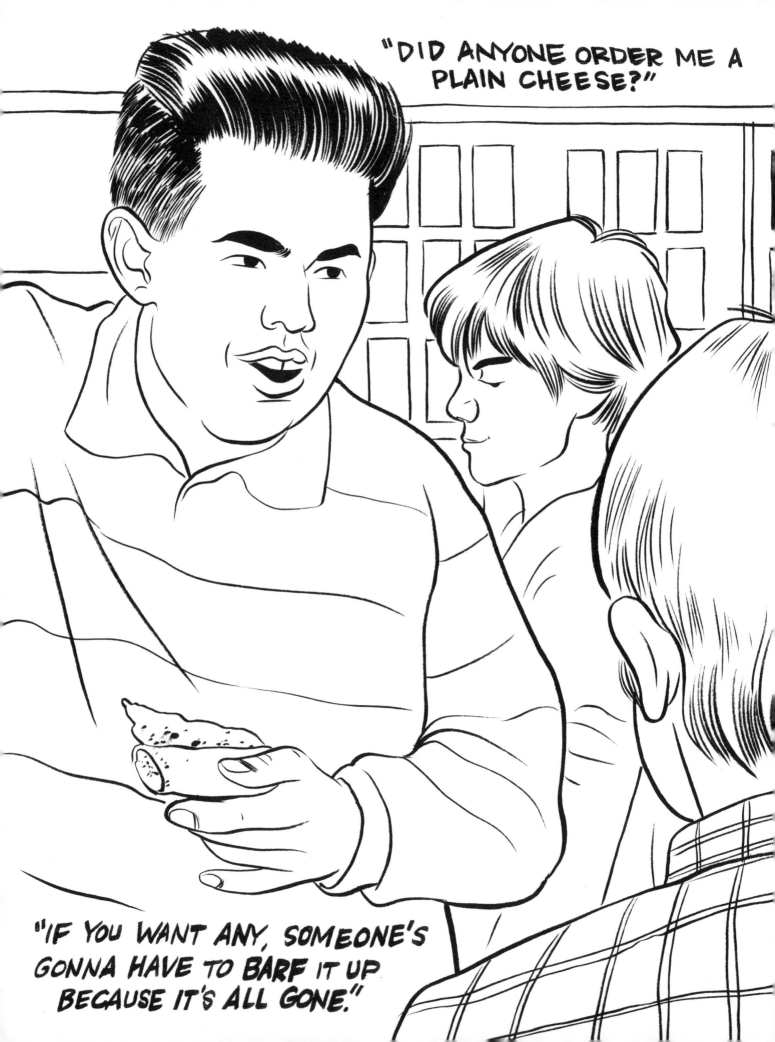

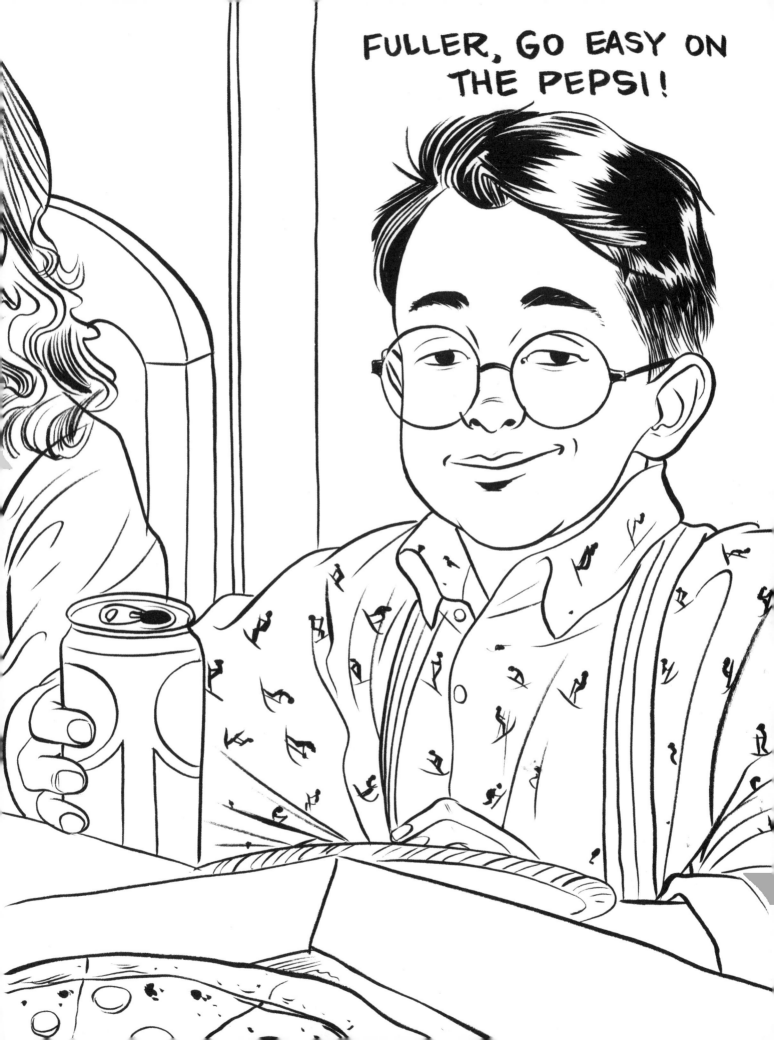

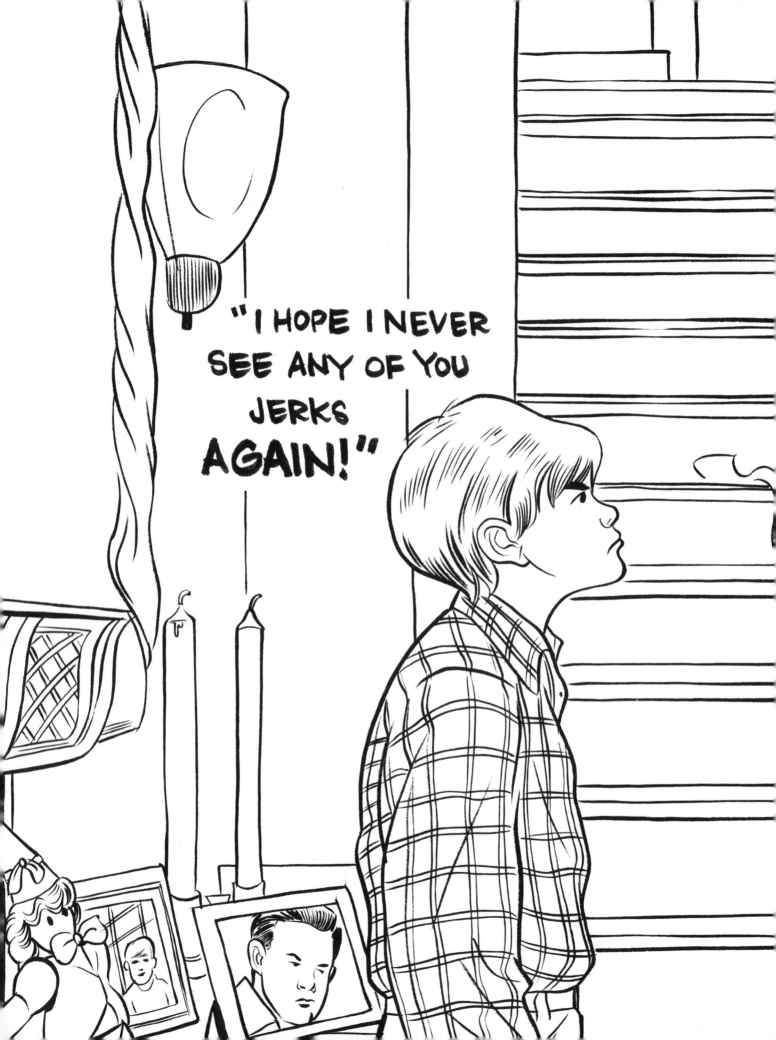

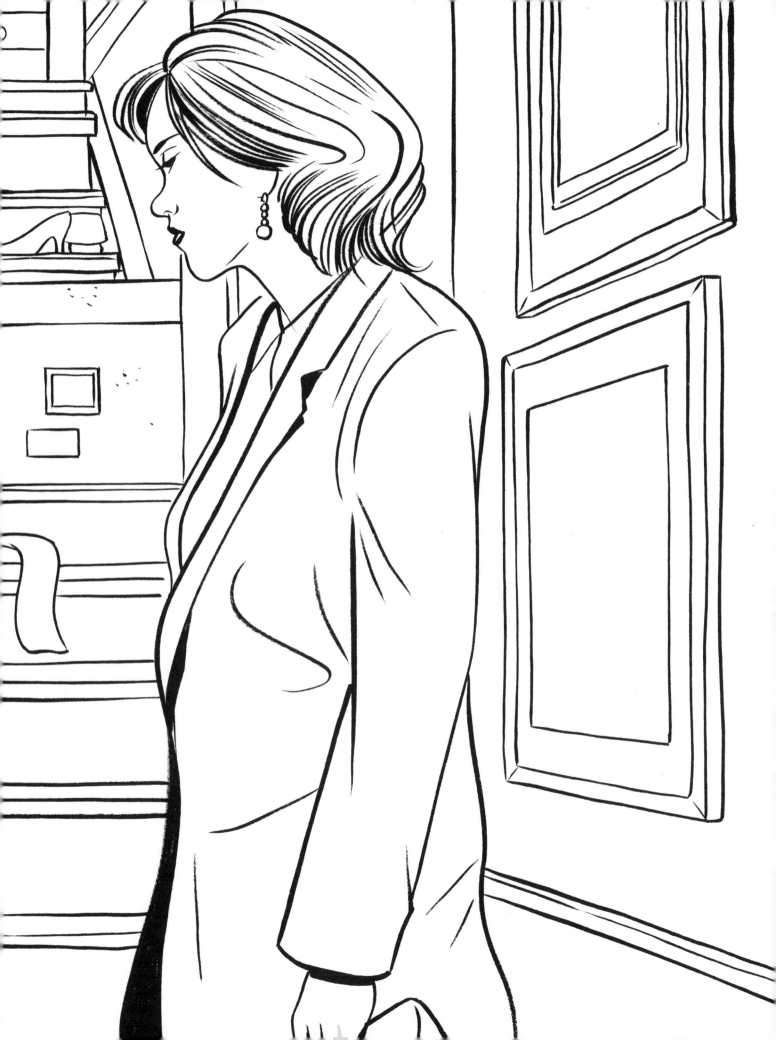

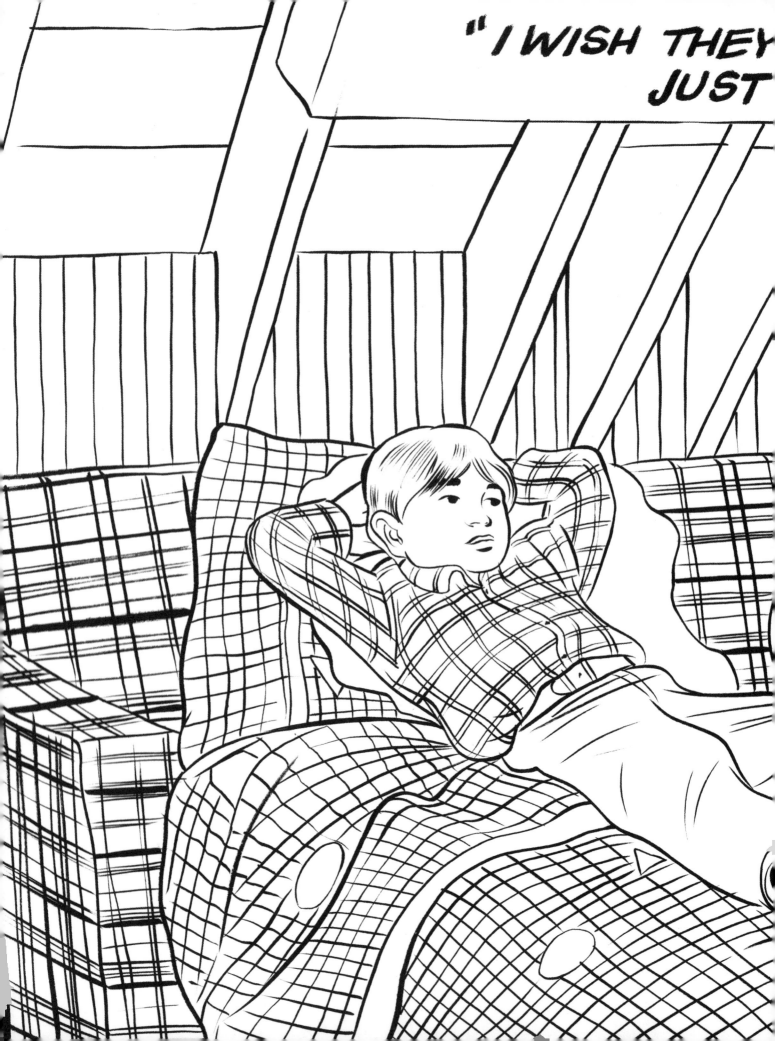

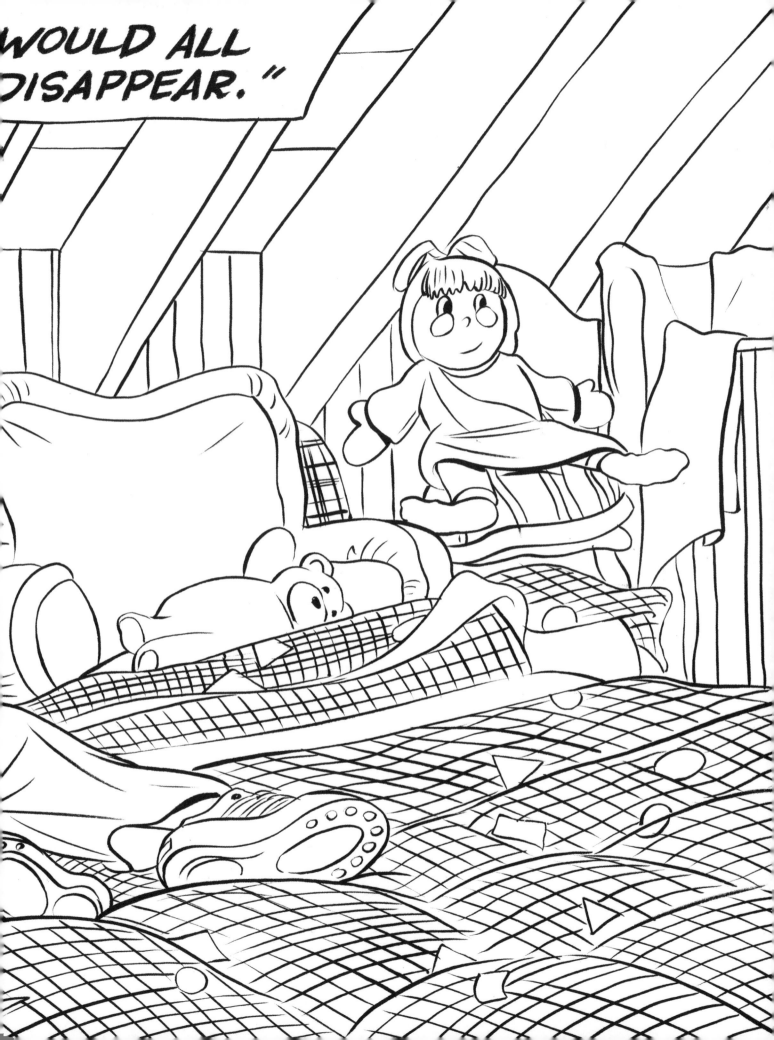

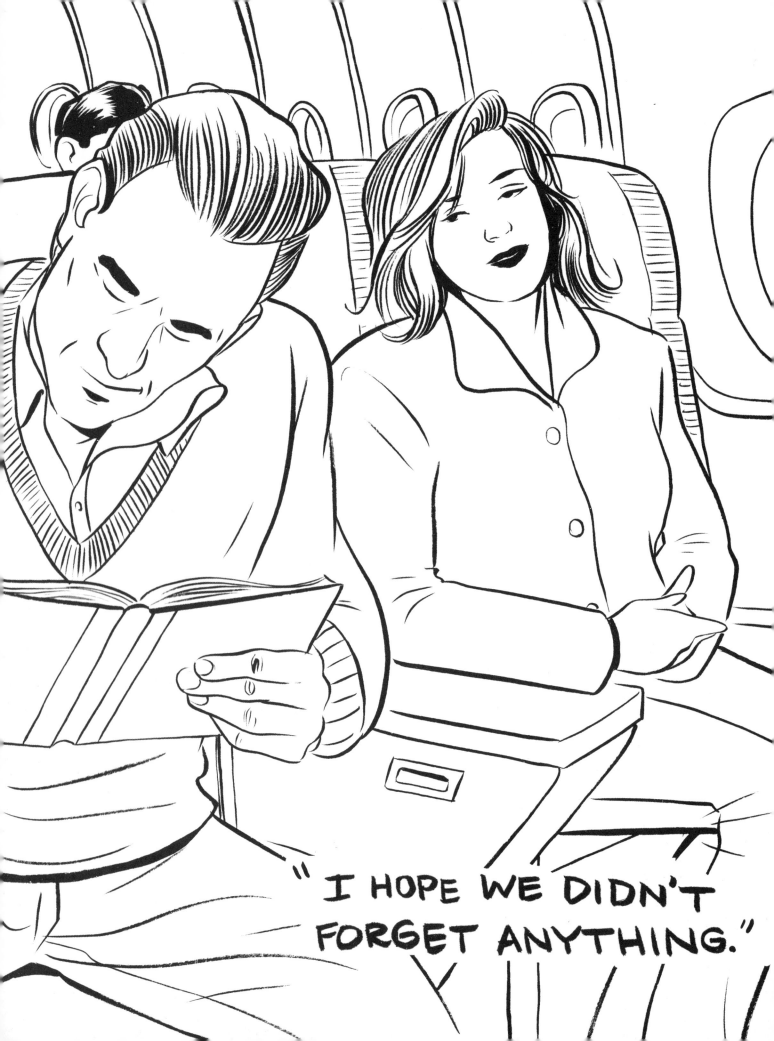

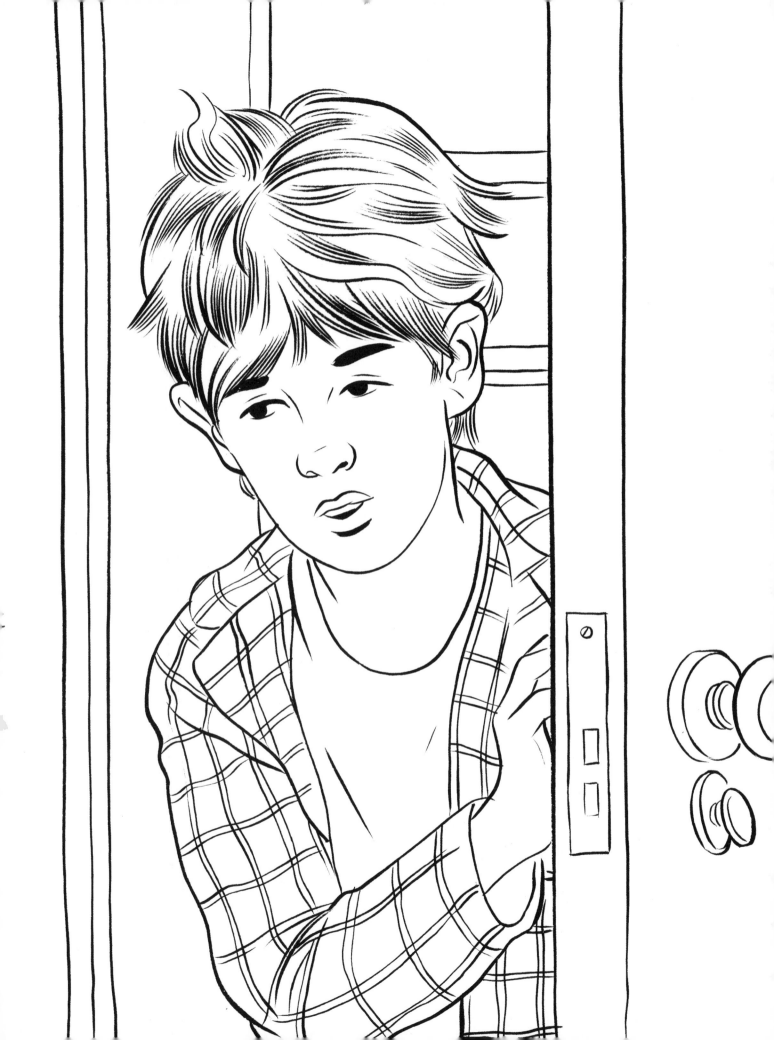

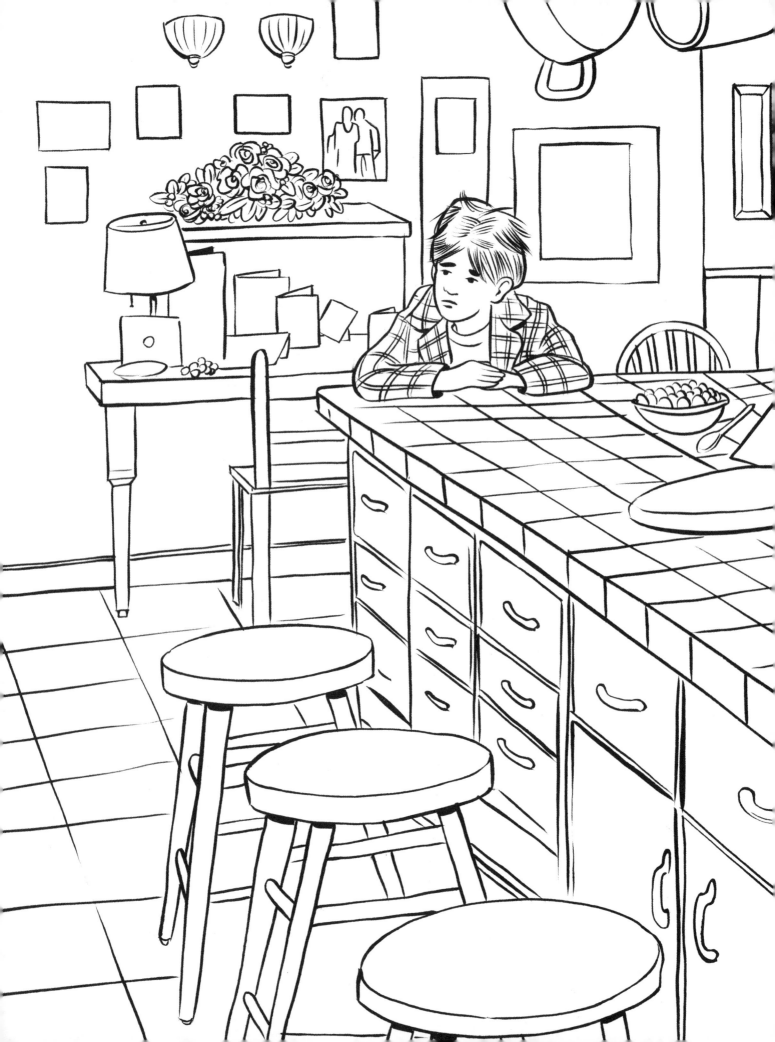

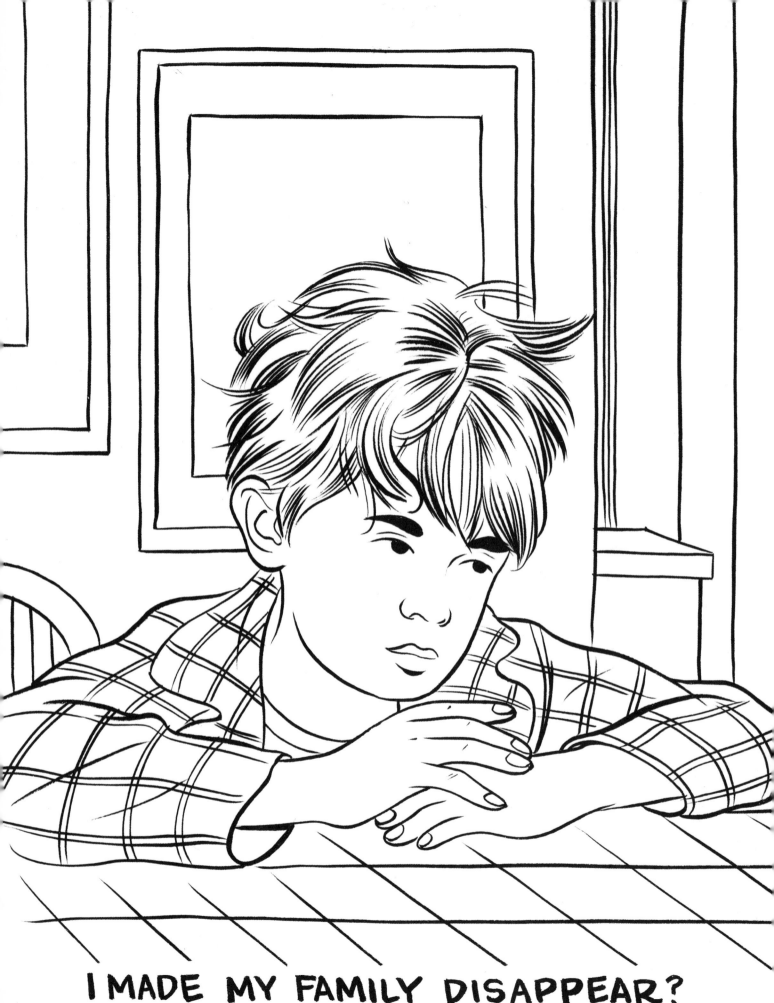

I MADE MY FAMILY DISAPPEAR?

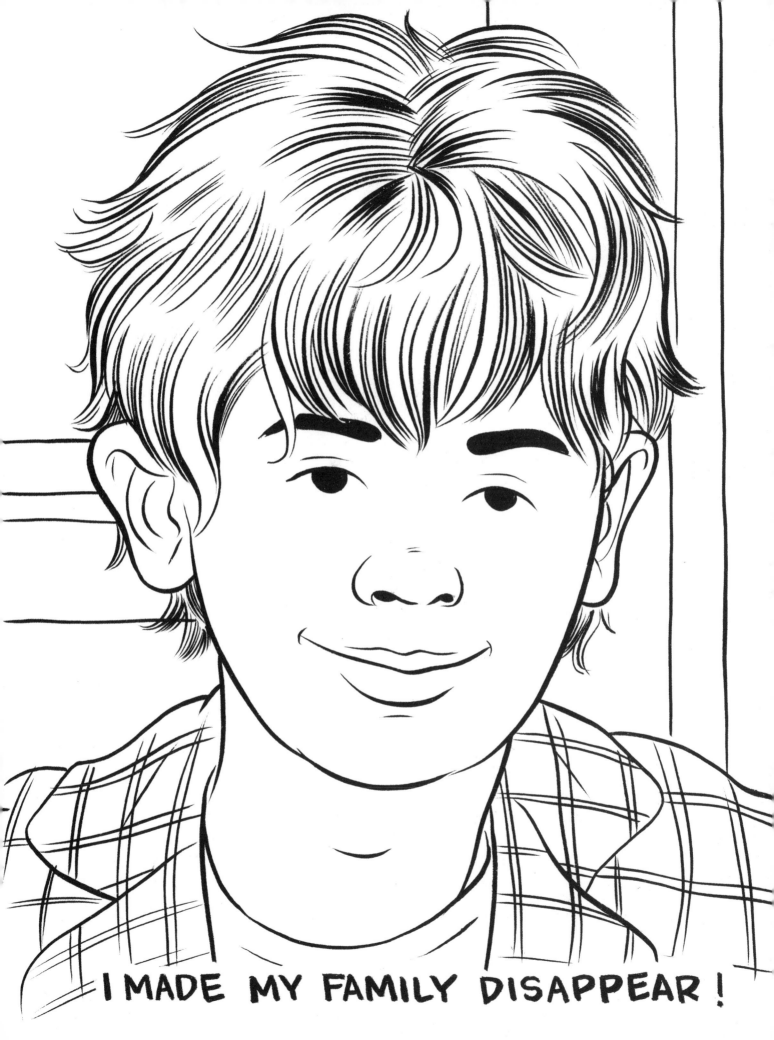

I MADE MY FAMILY DISAPPEAR!

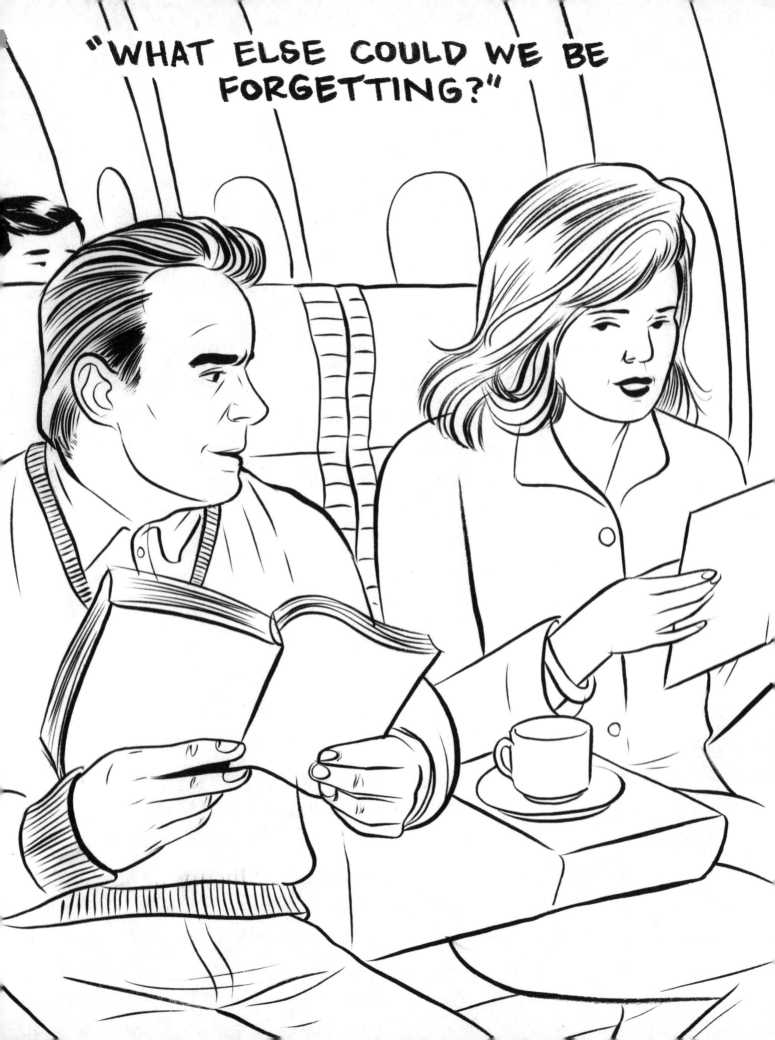

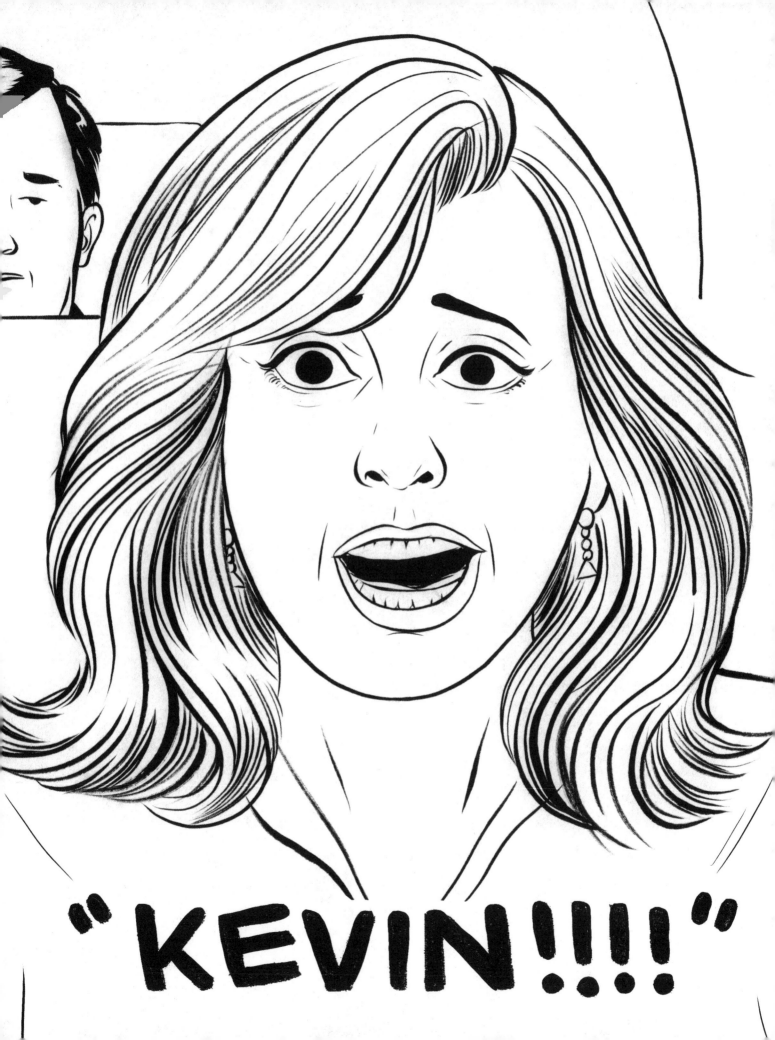

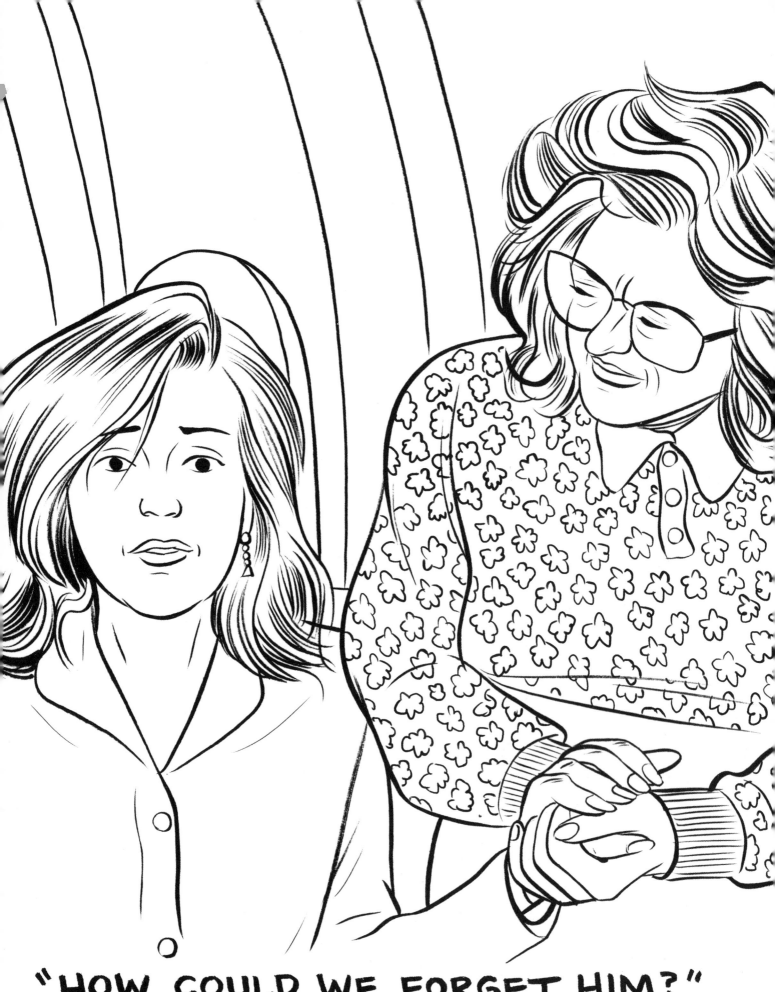

"HOW COULD WE FORGET HIM?"

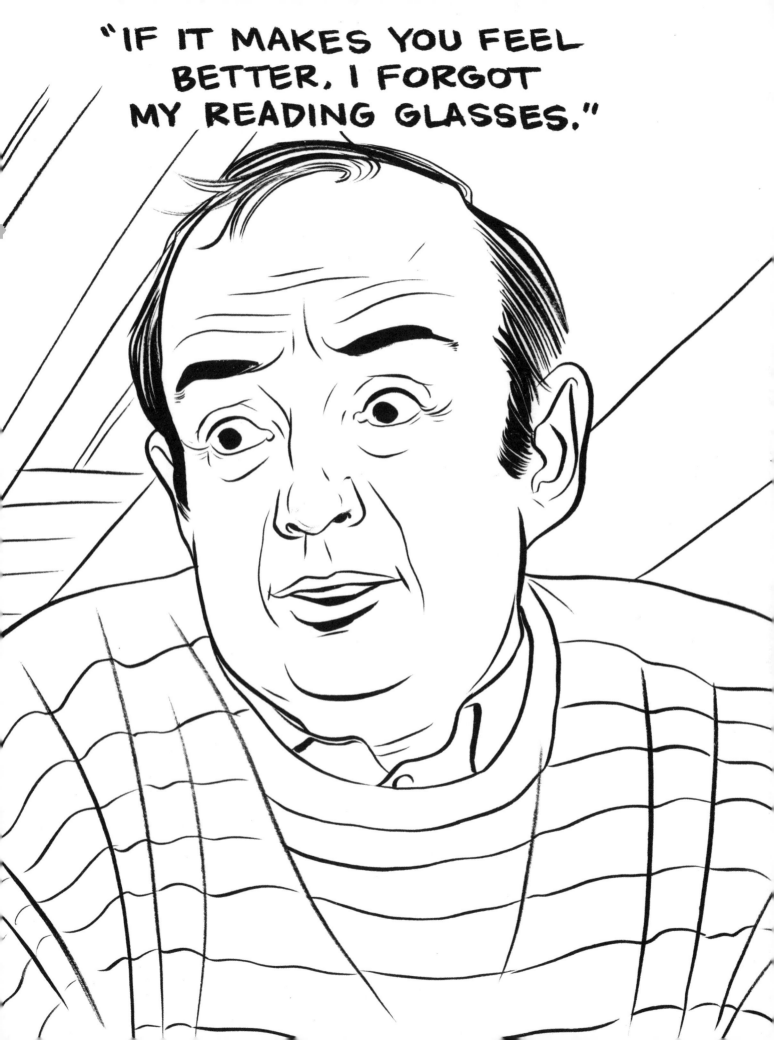

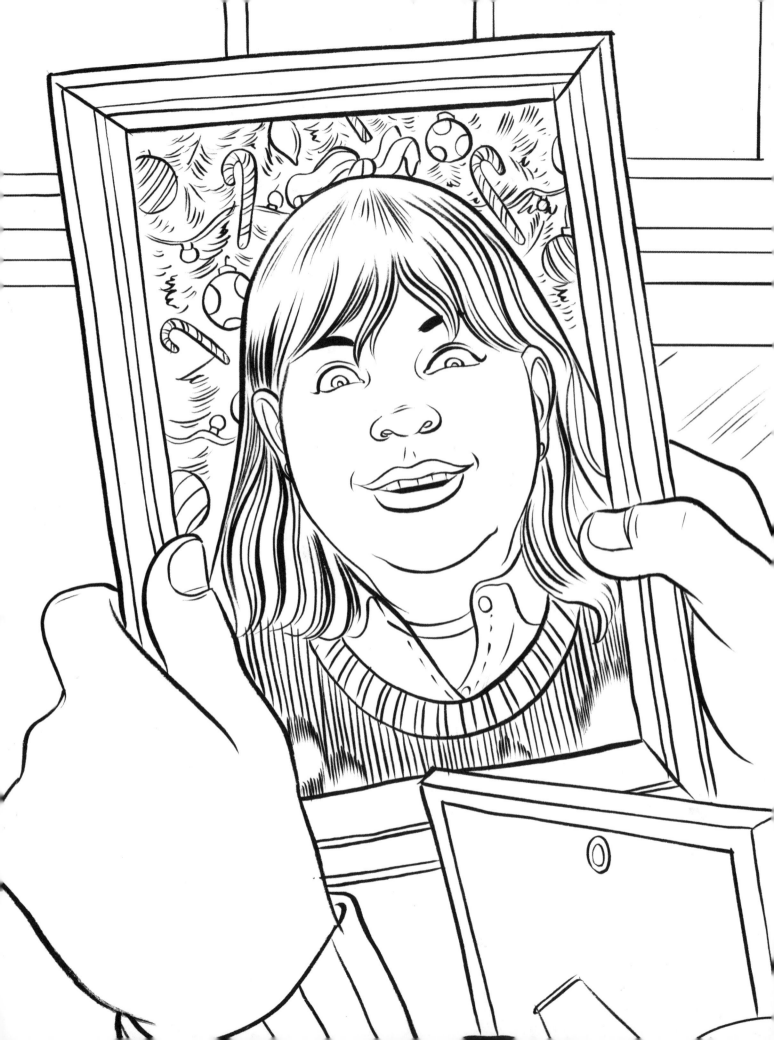

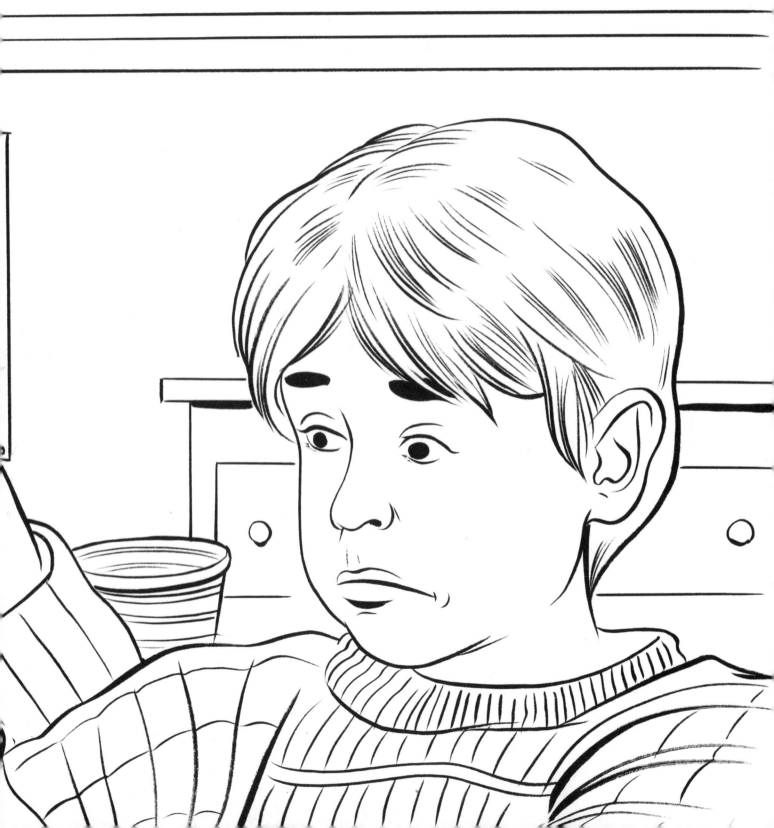

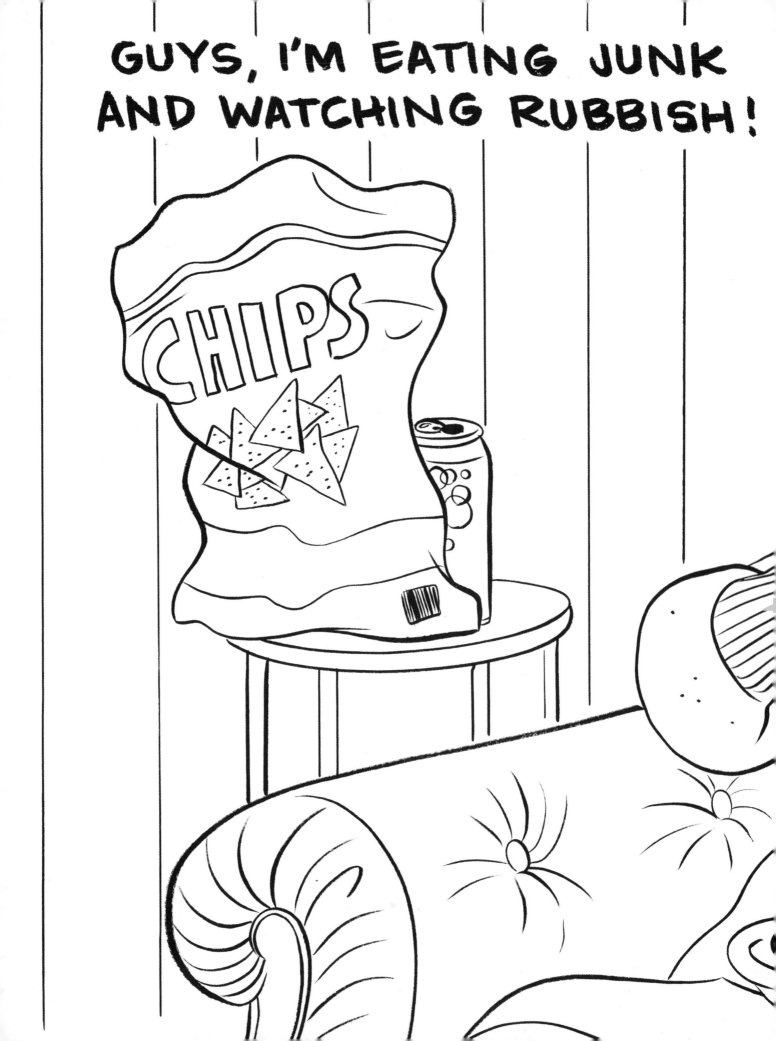

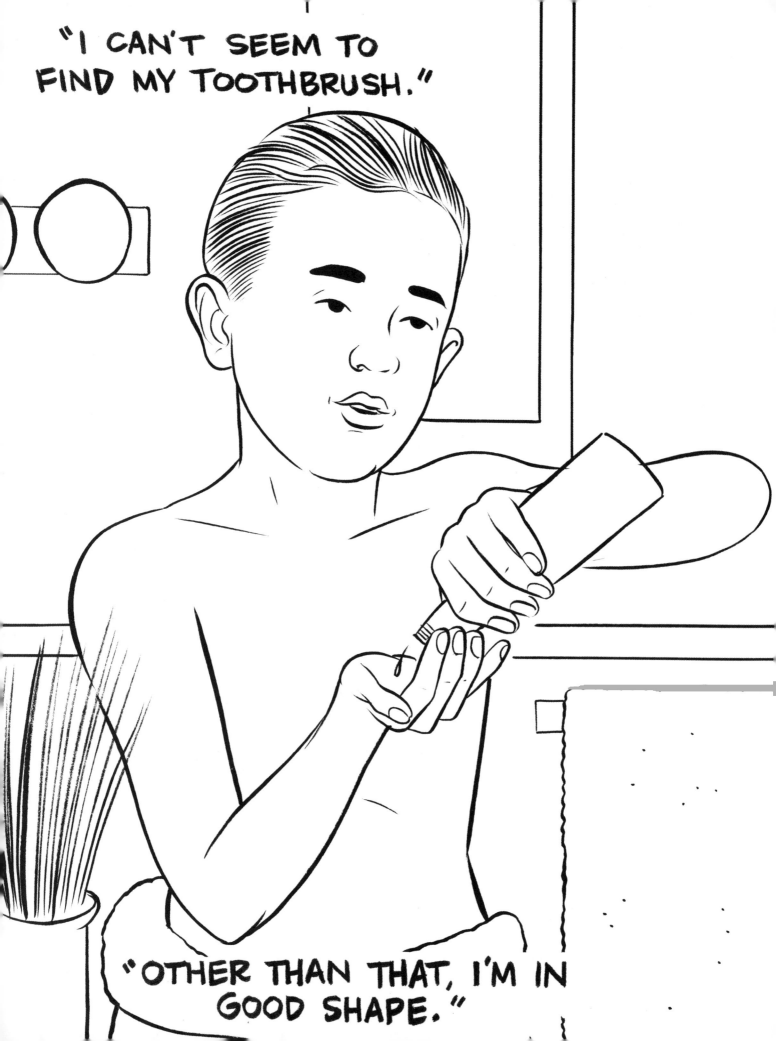

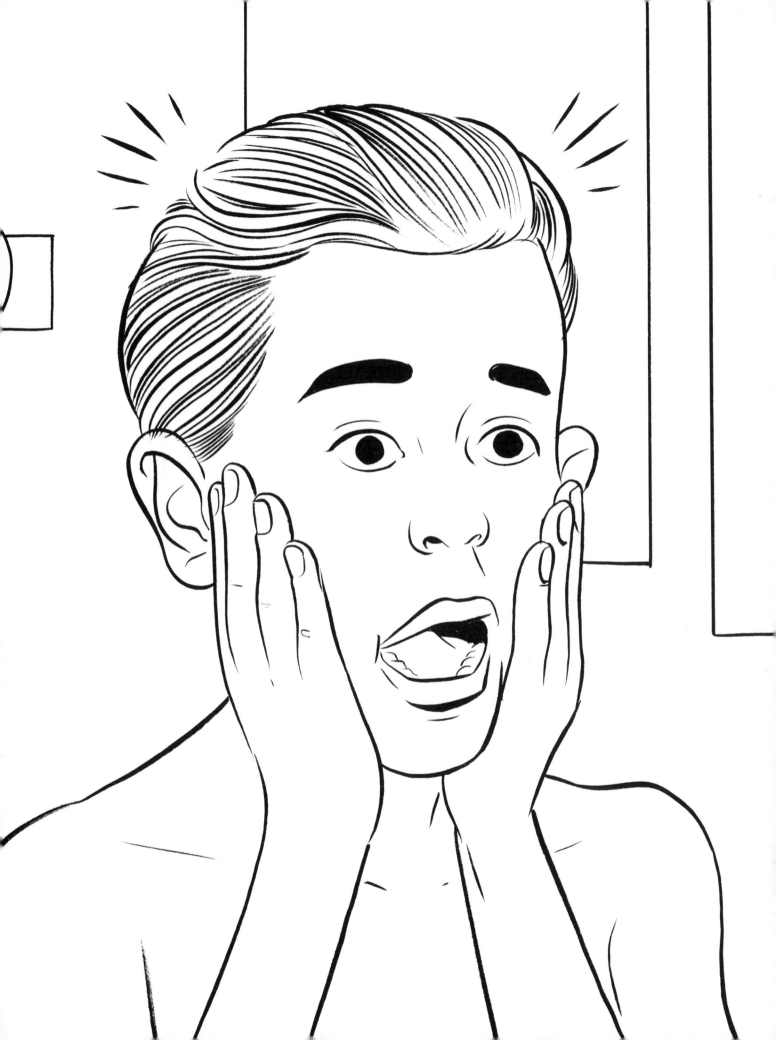

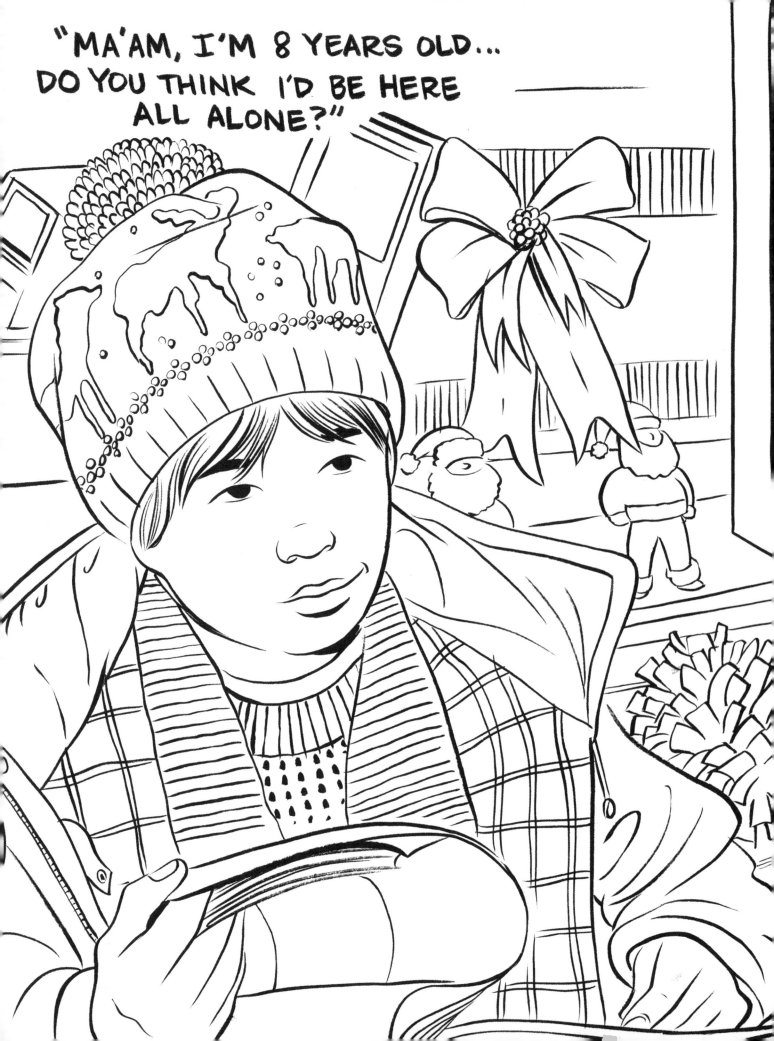

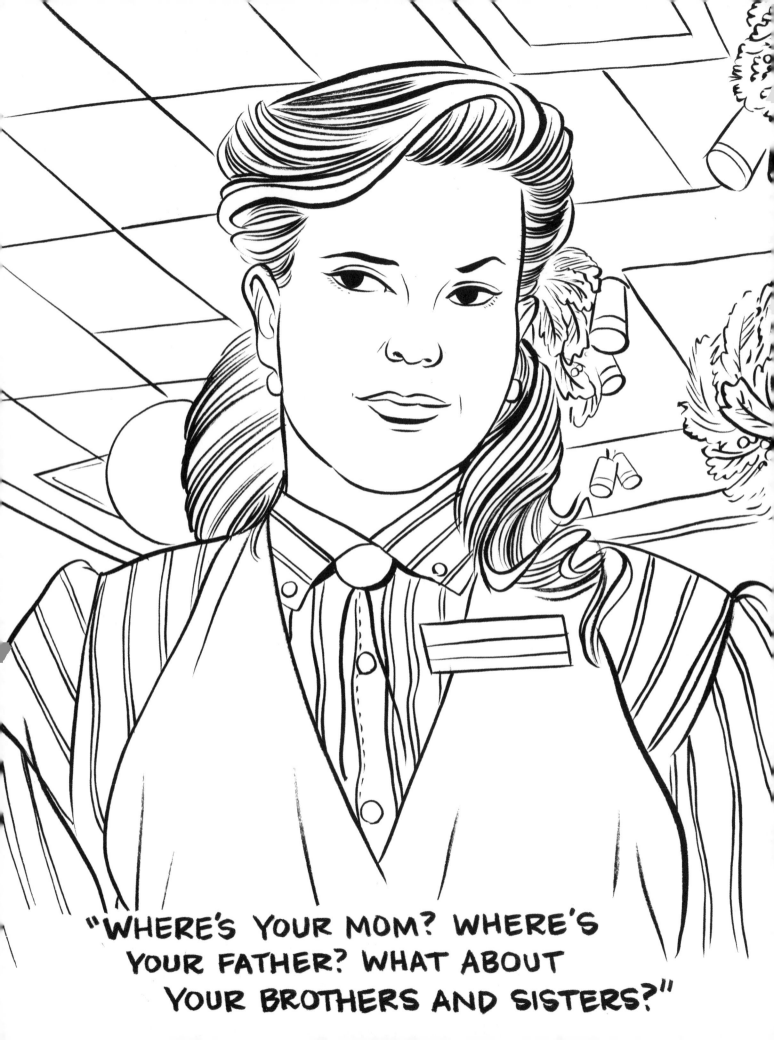

"WHERE'S YOUR MOM? WHERE'S YOUR FATHER? WHAT ABOUT YOUR BROTHERS AND SISTERS?"

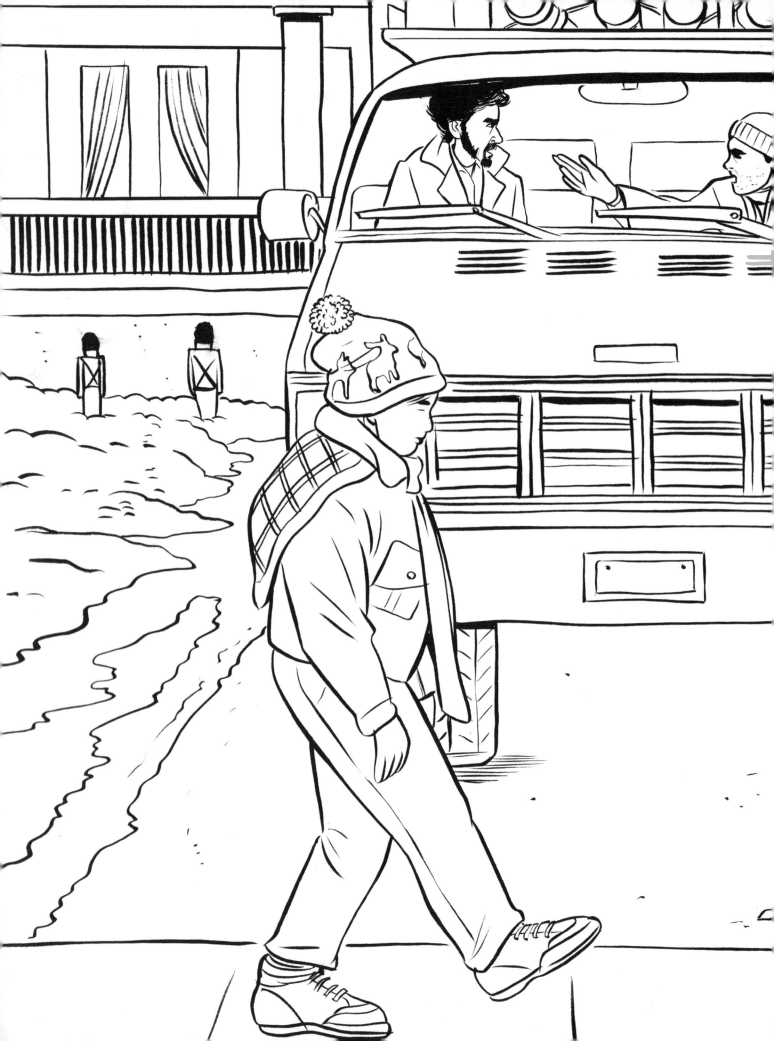

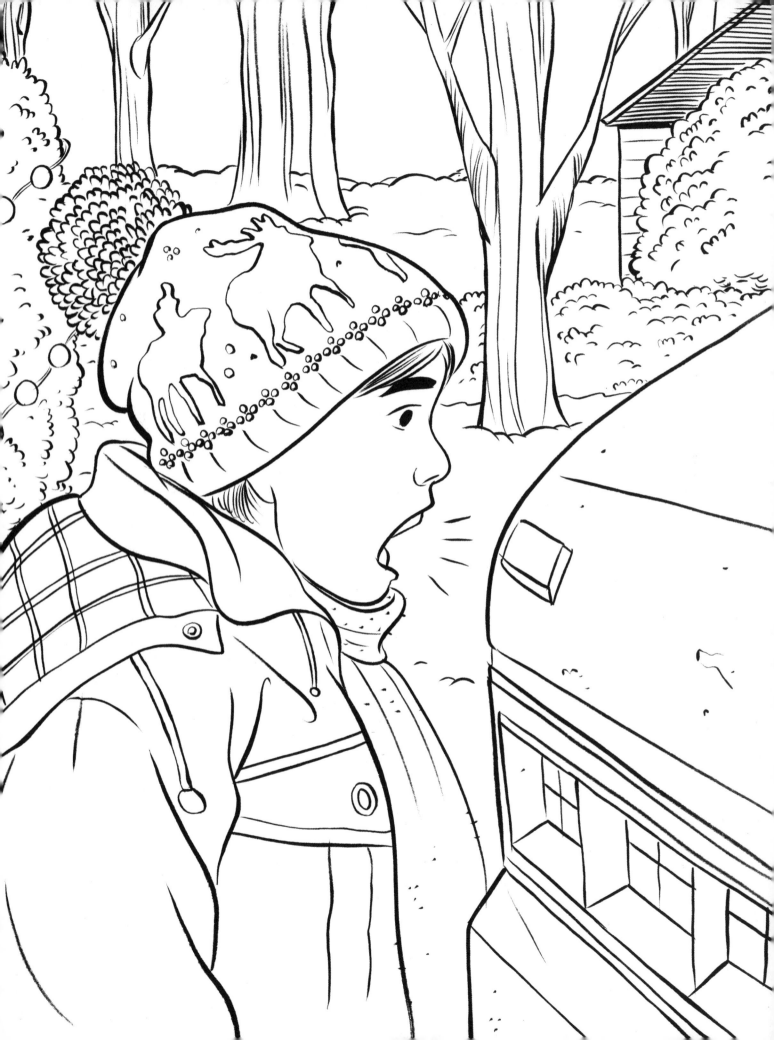

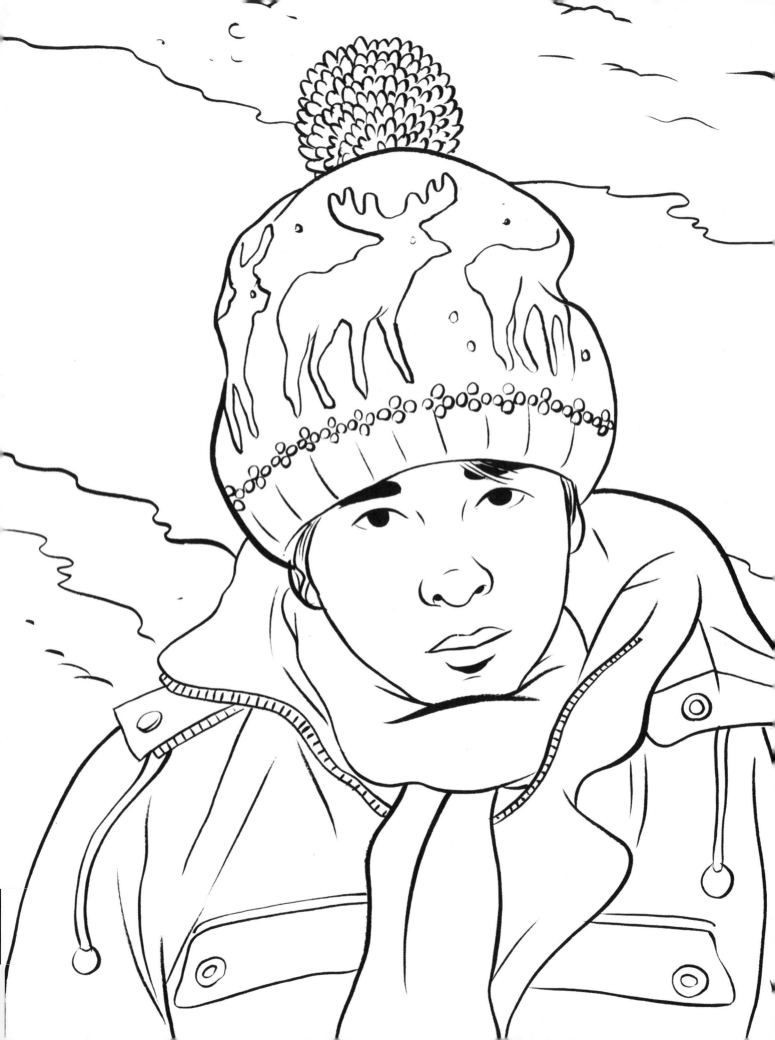

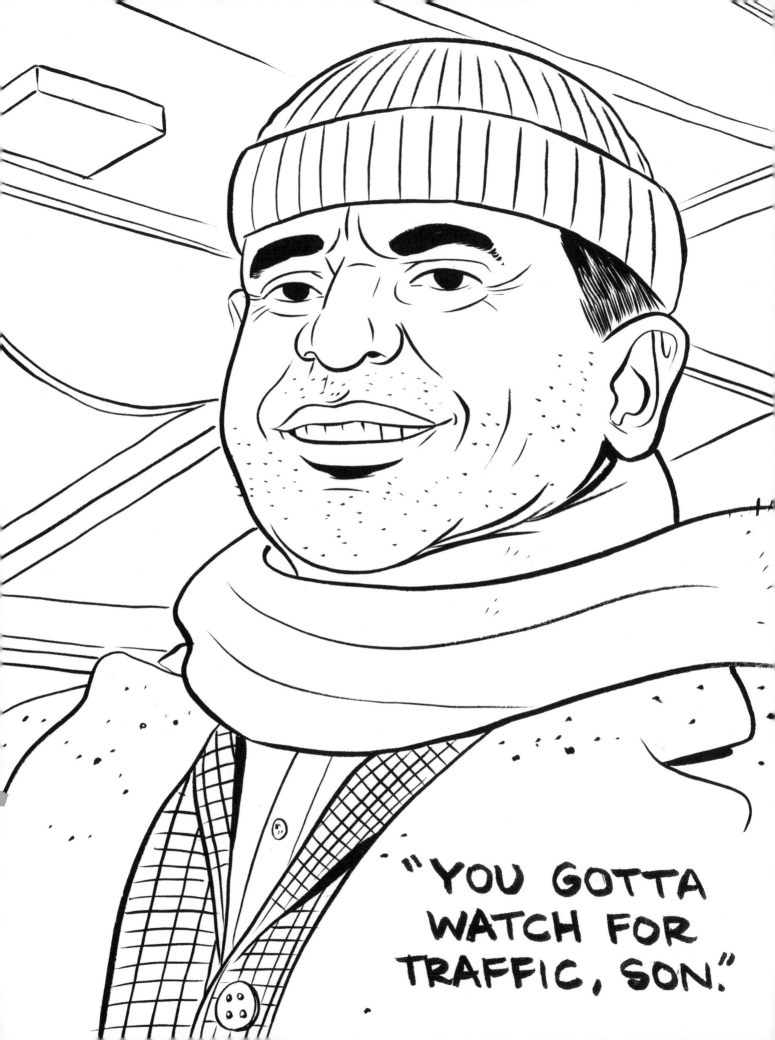

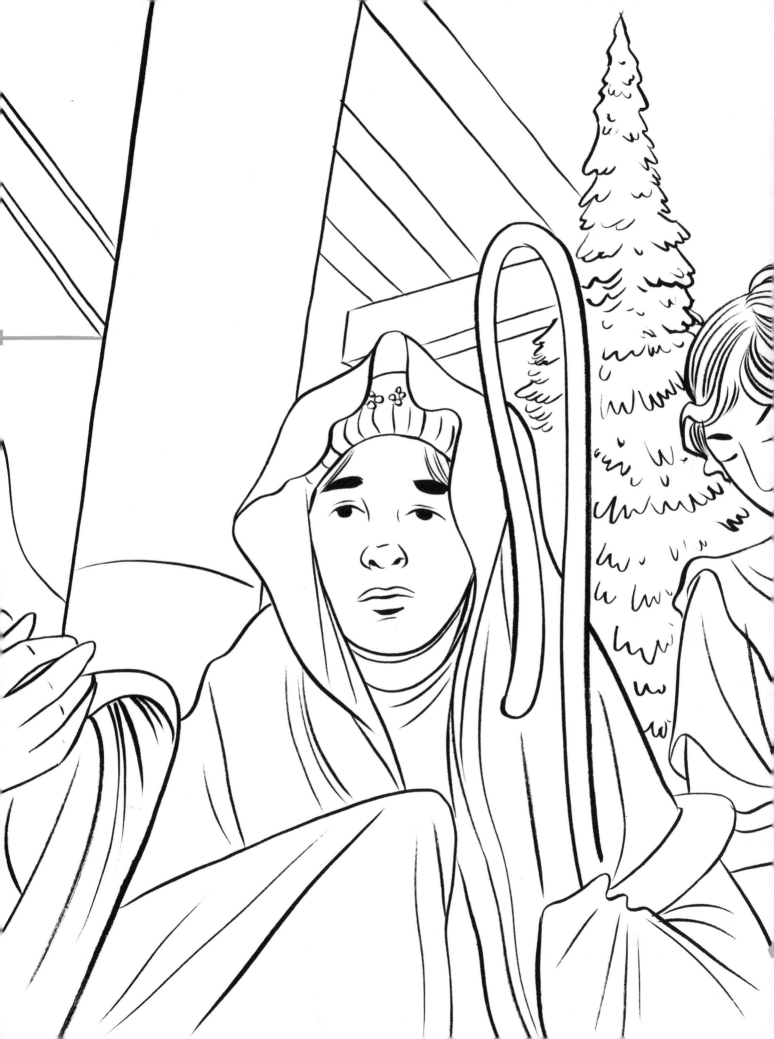

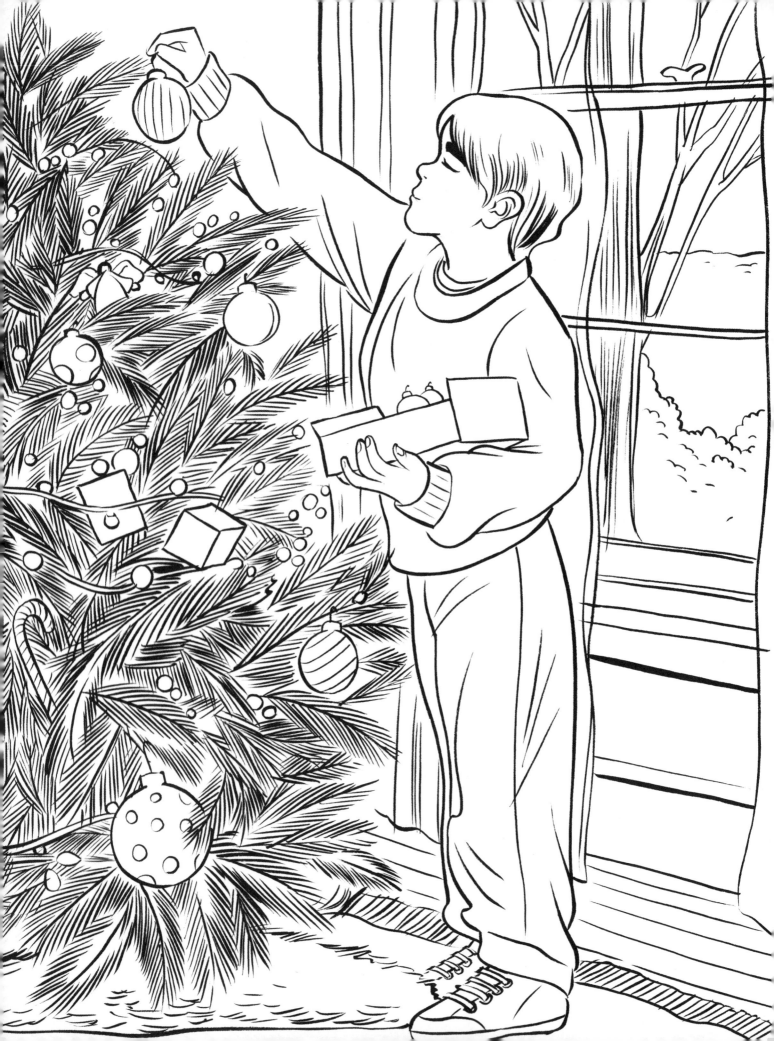

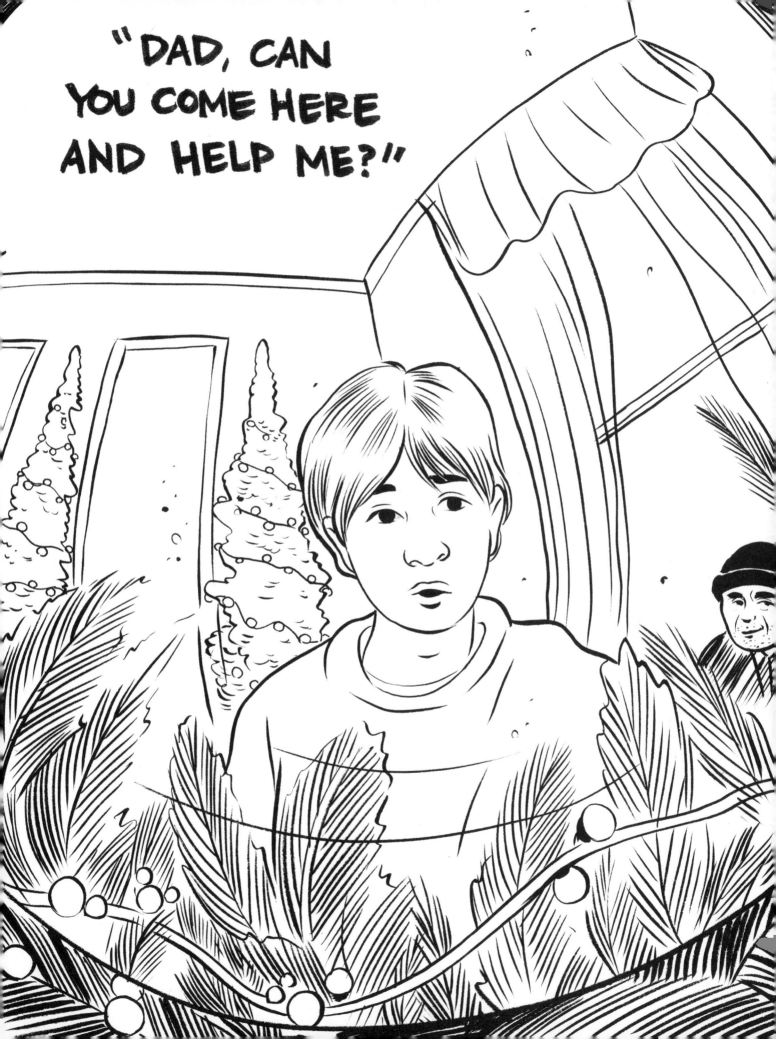

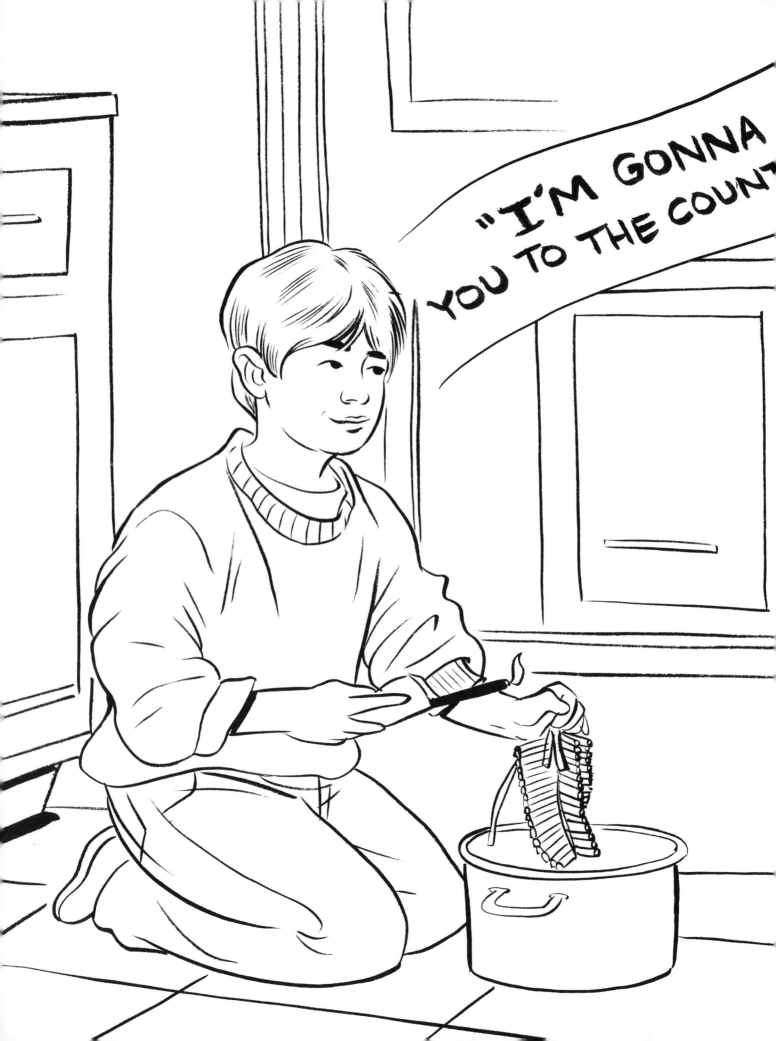

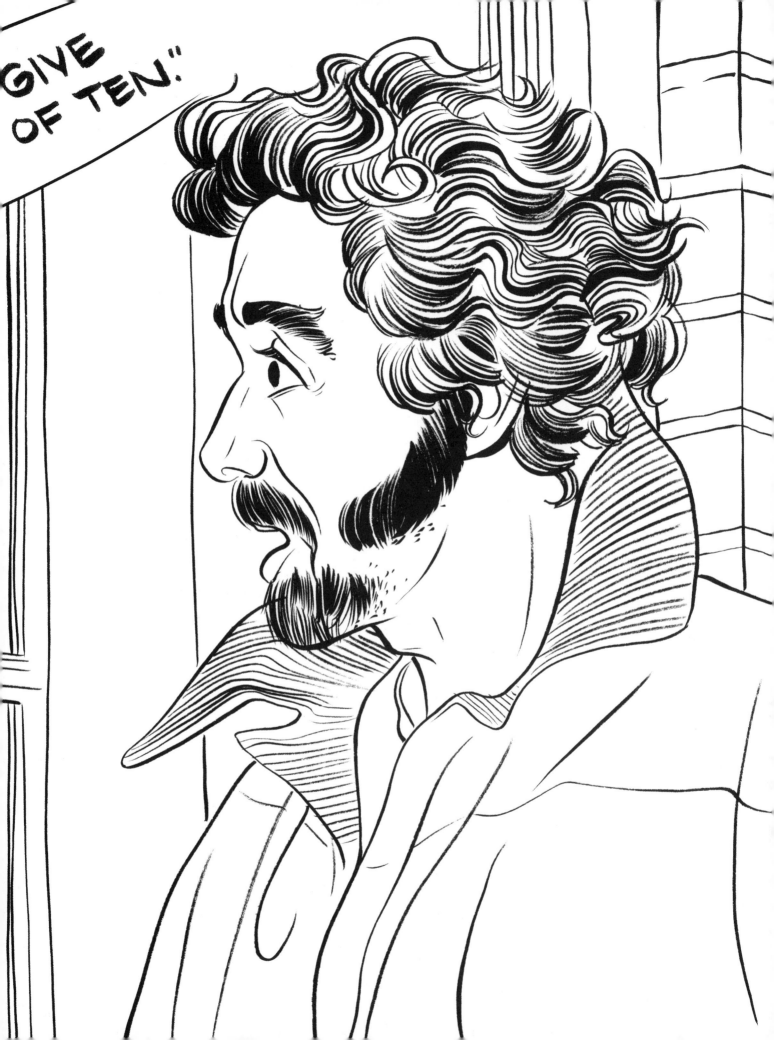

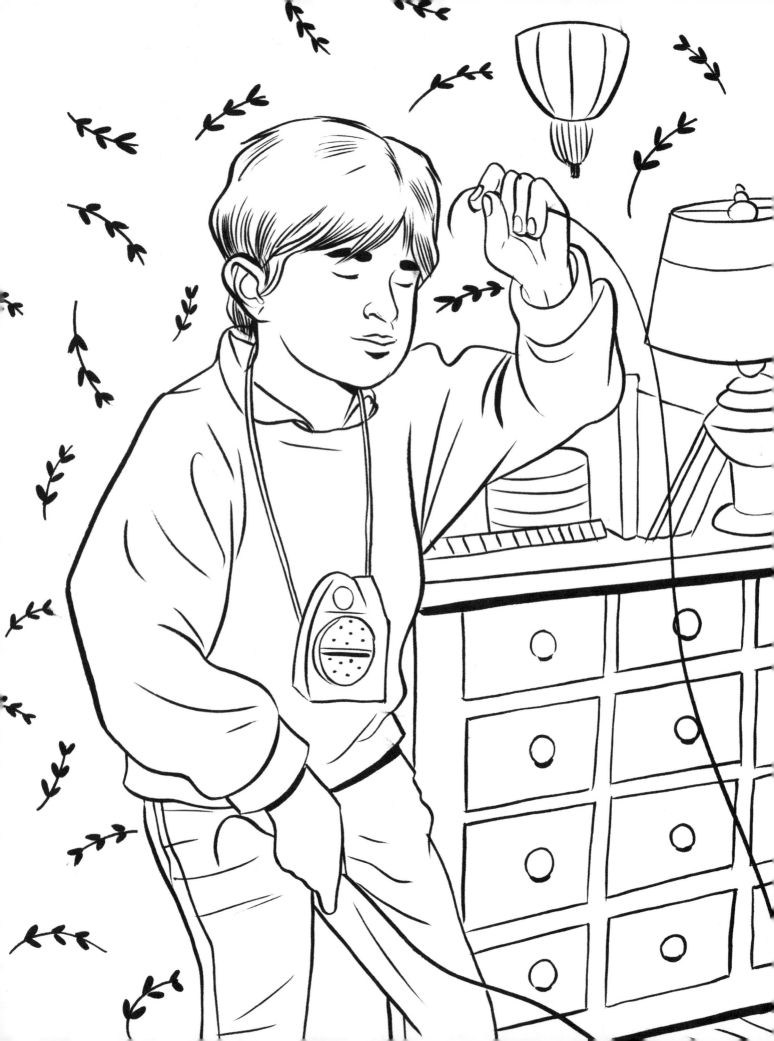

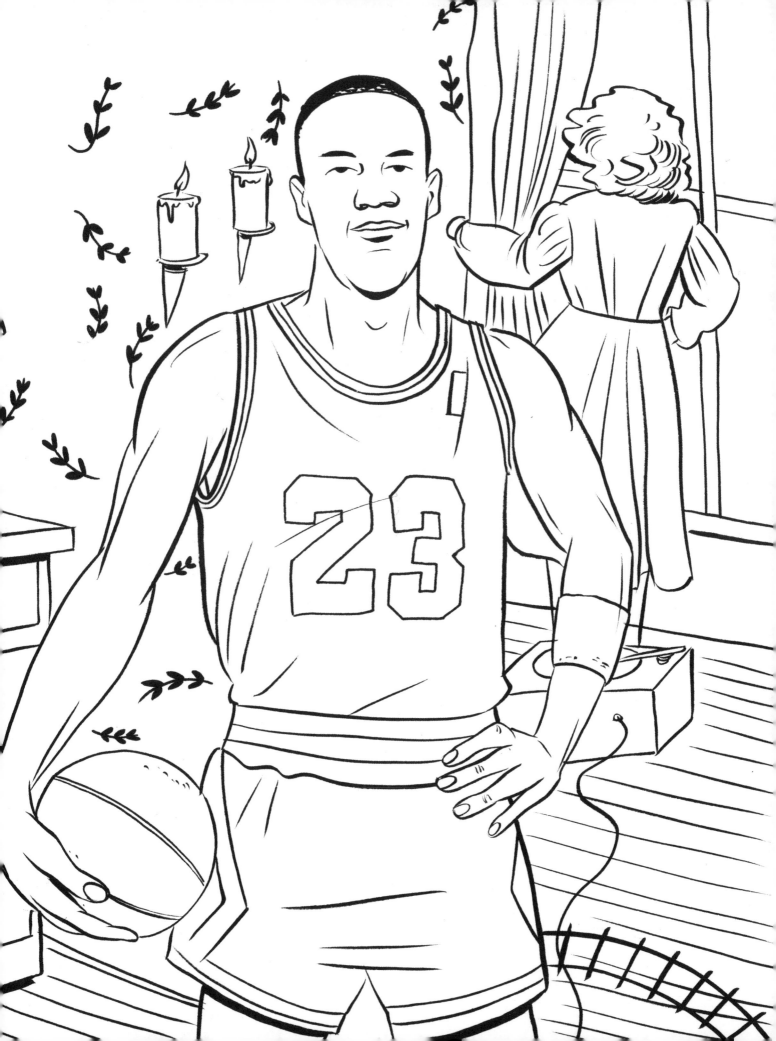

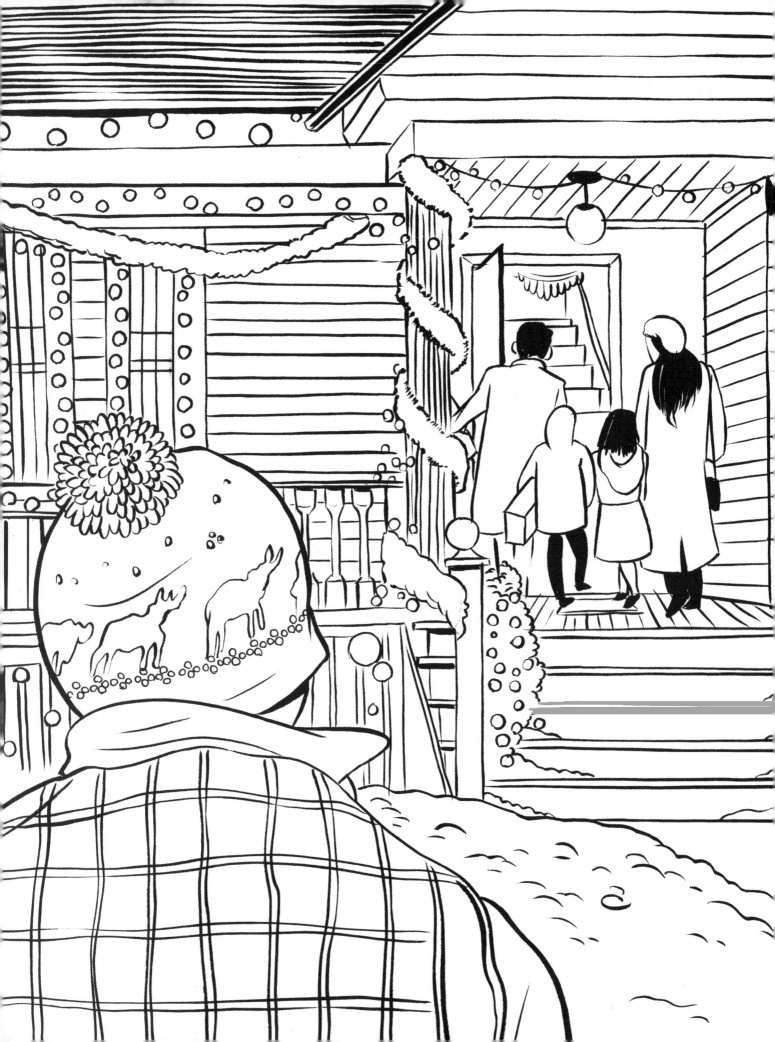

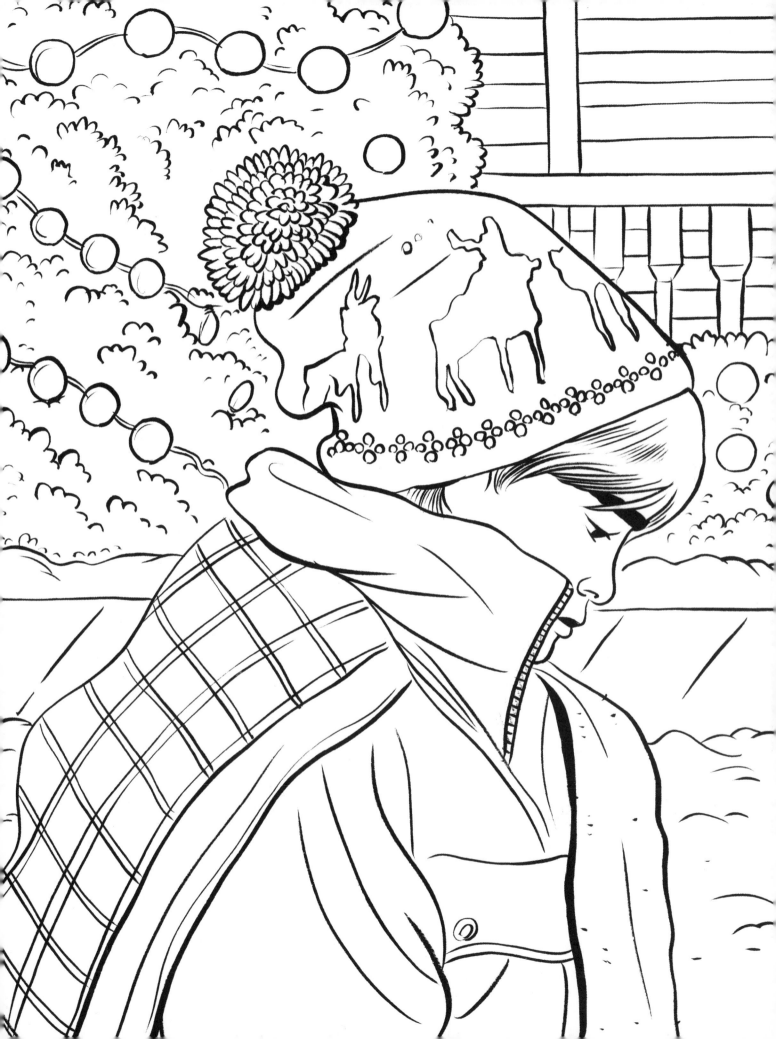

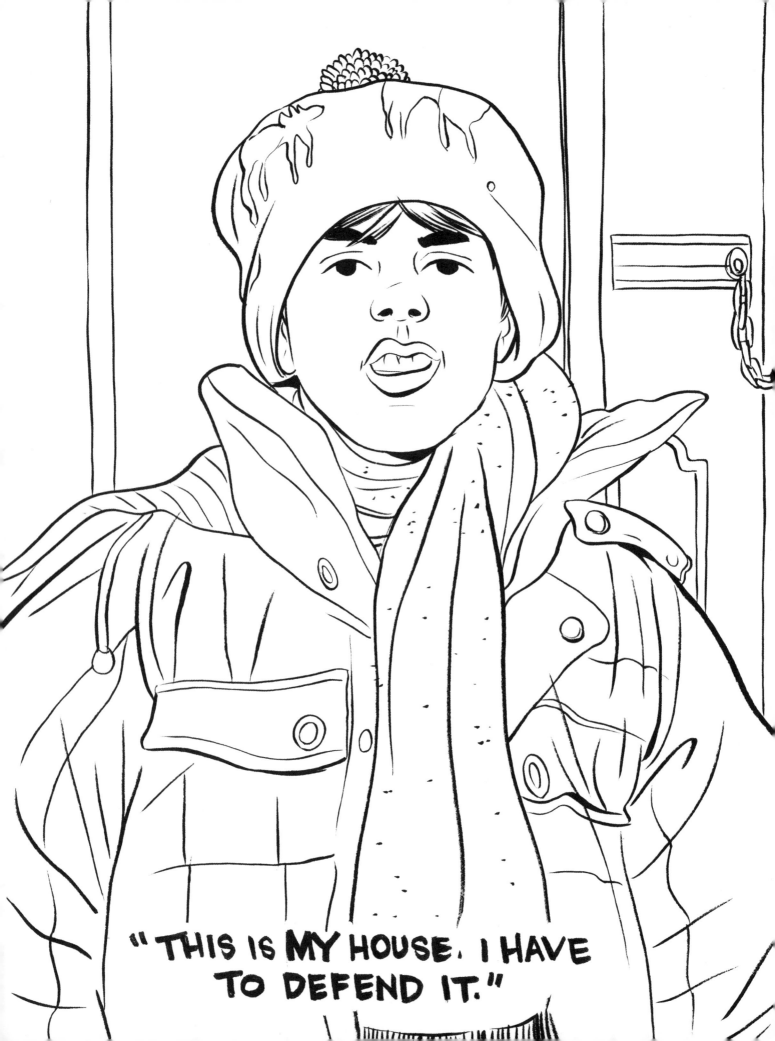

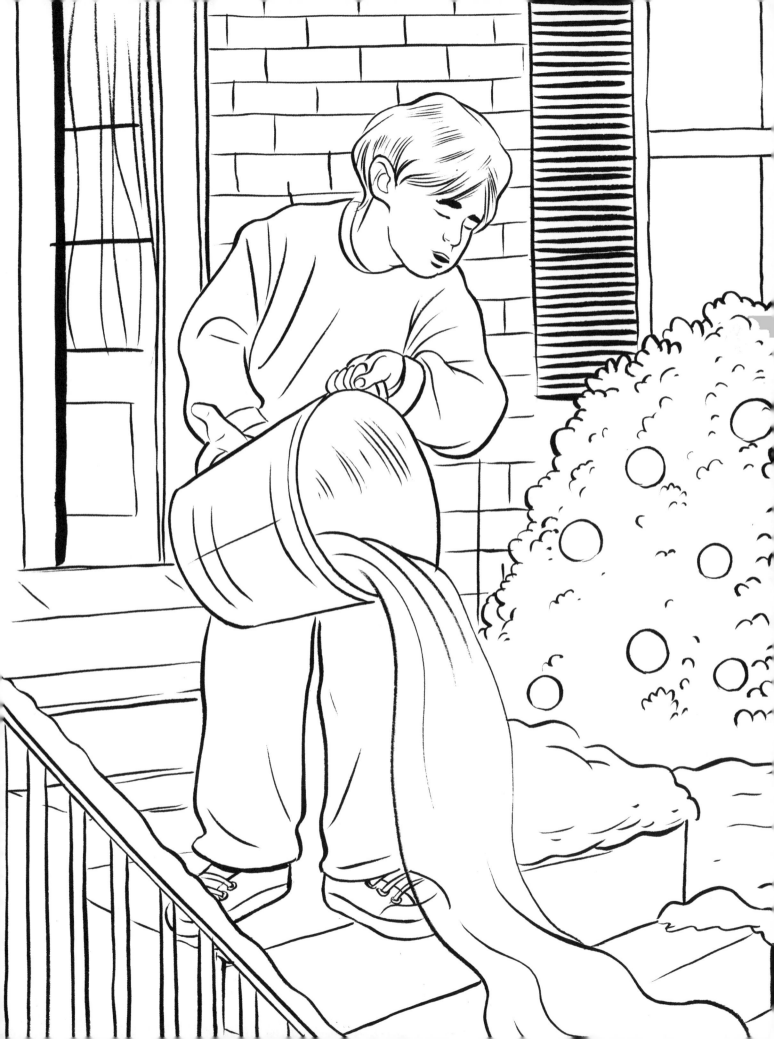

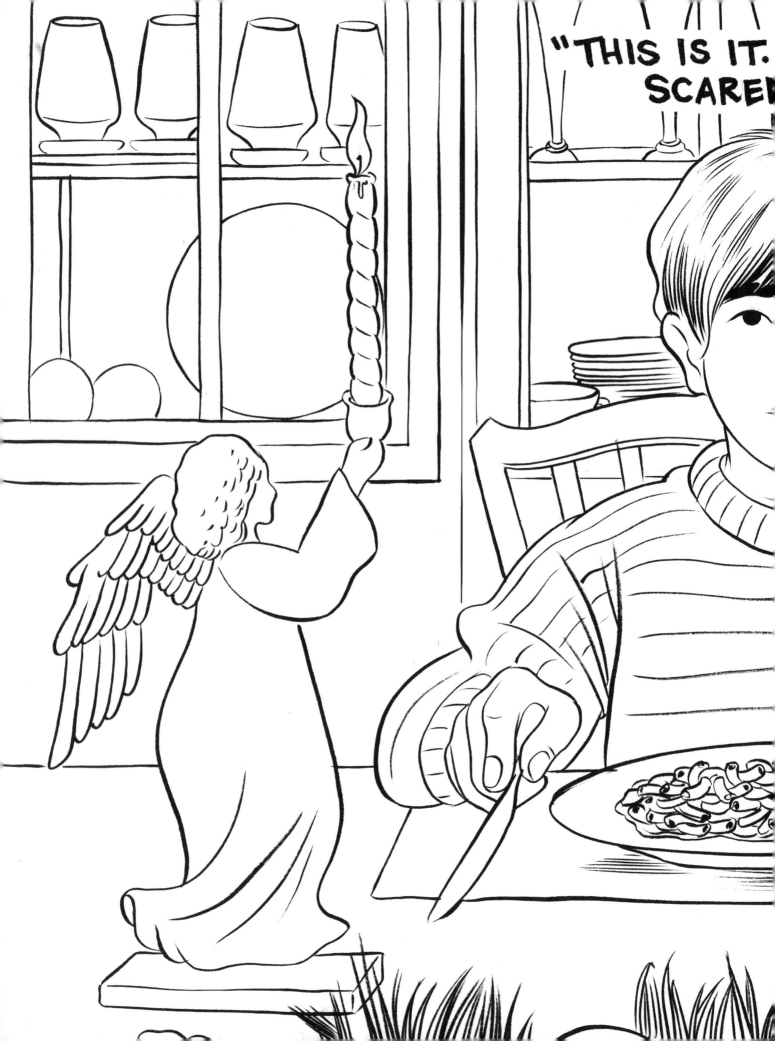

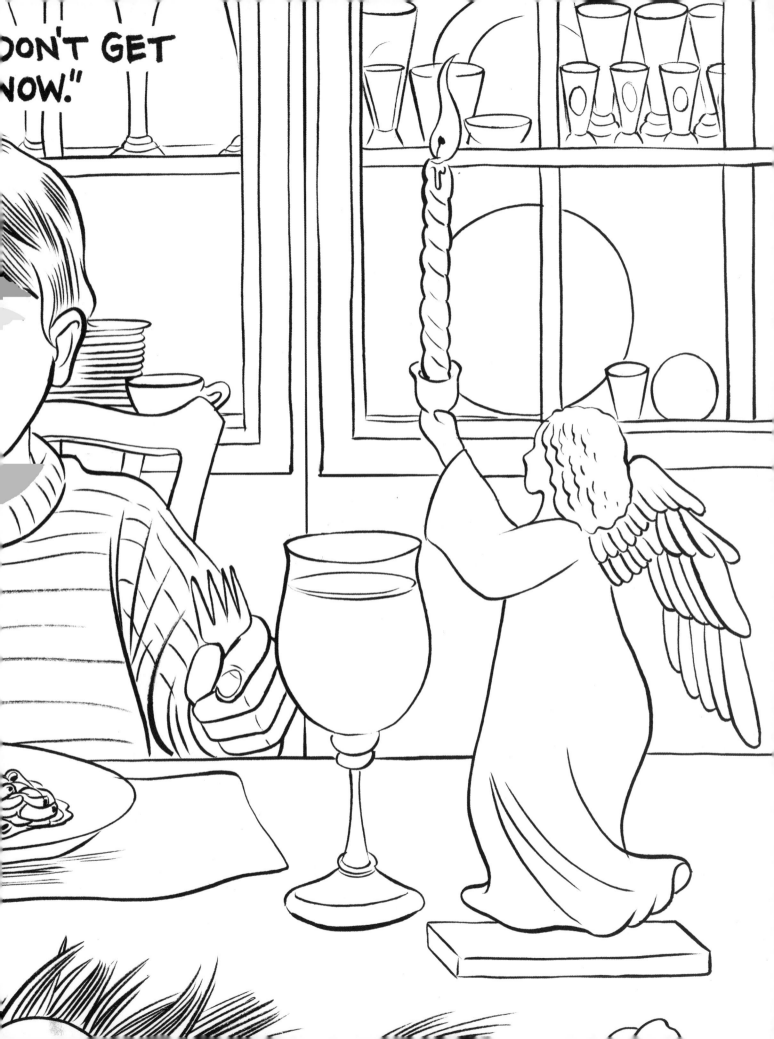

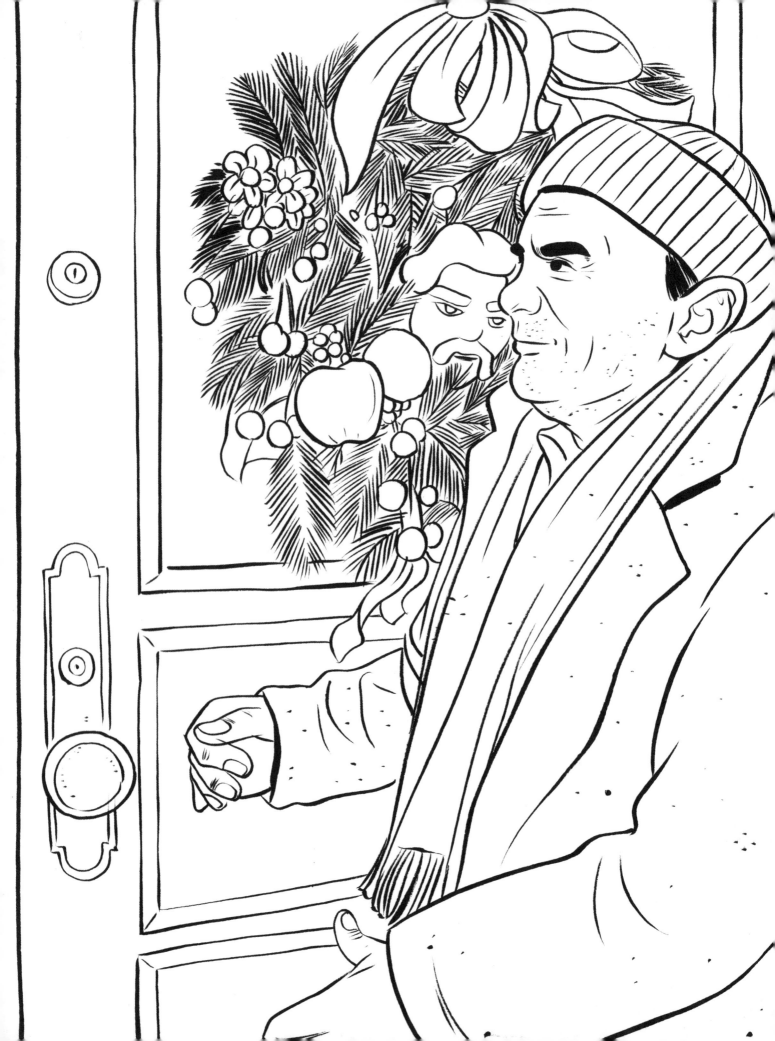

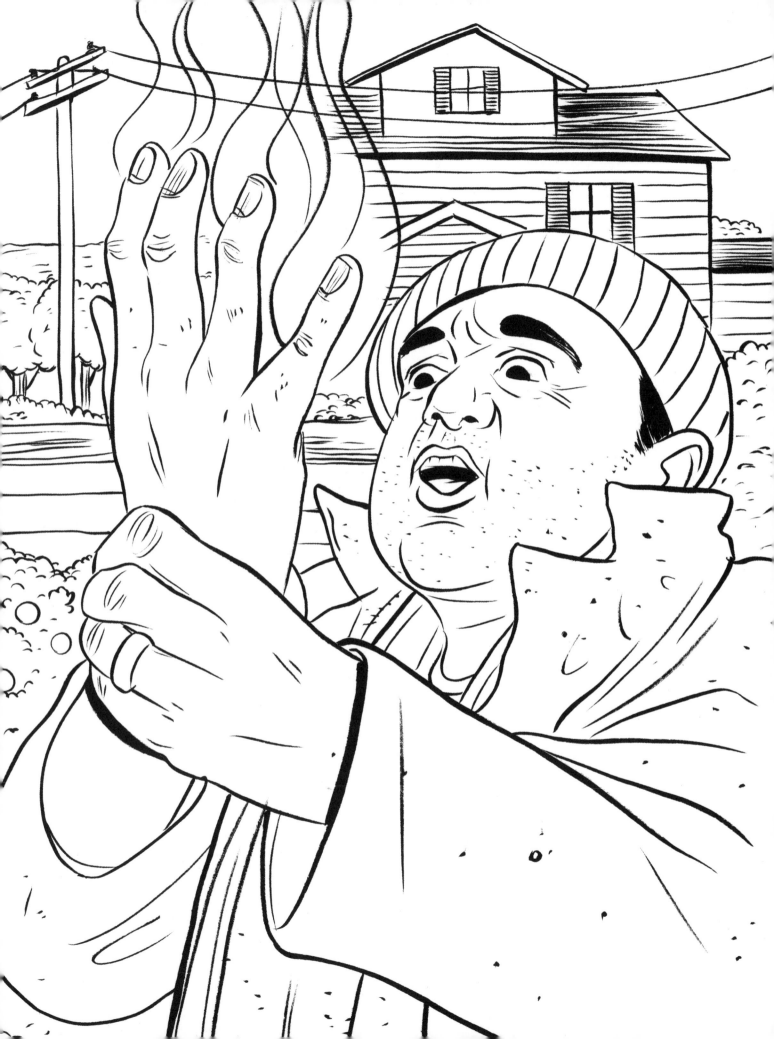

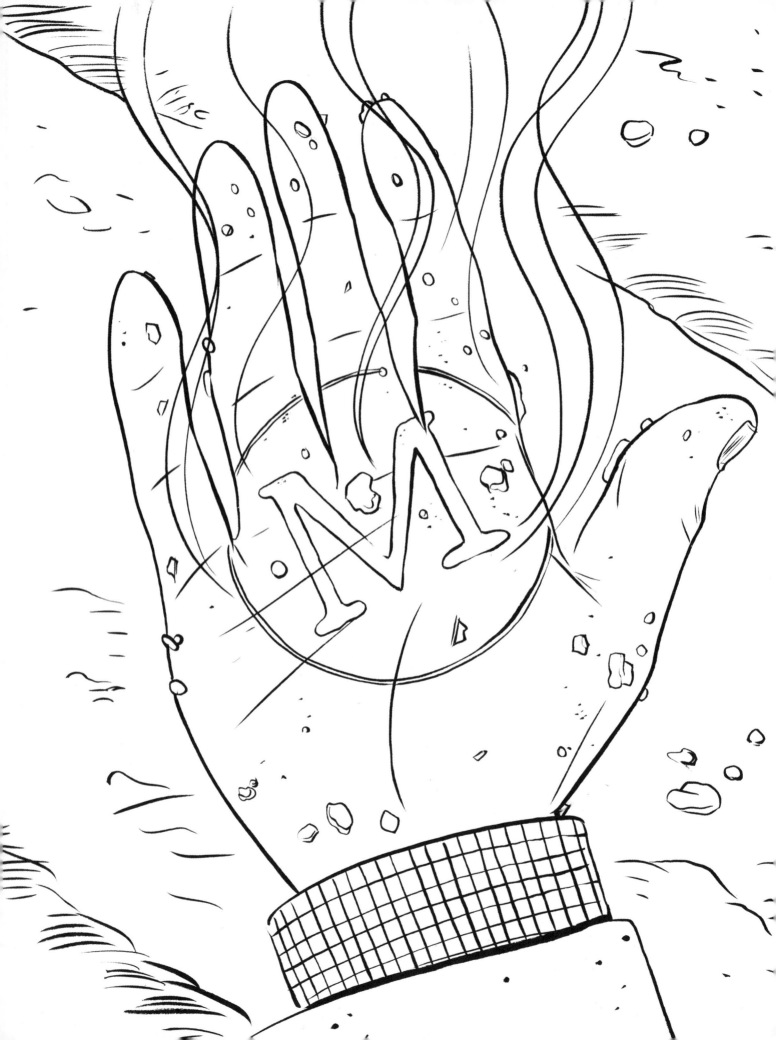

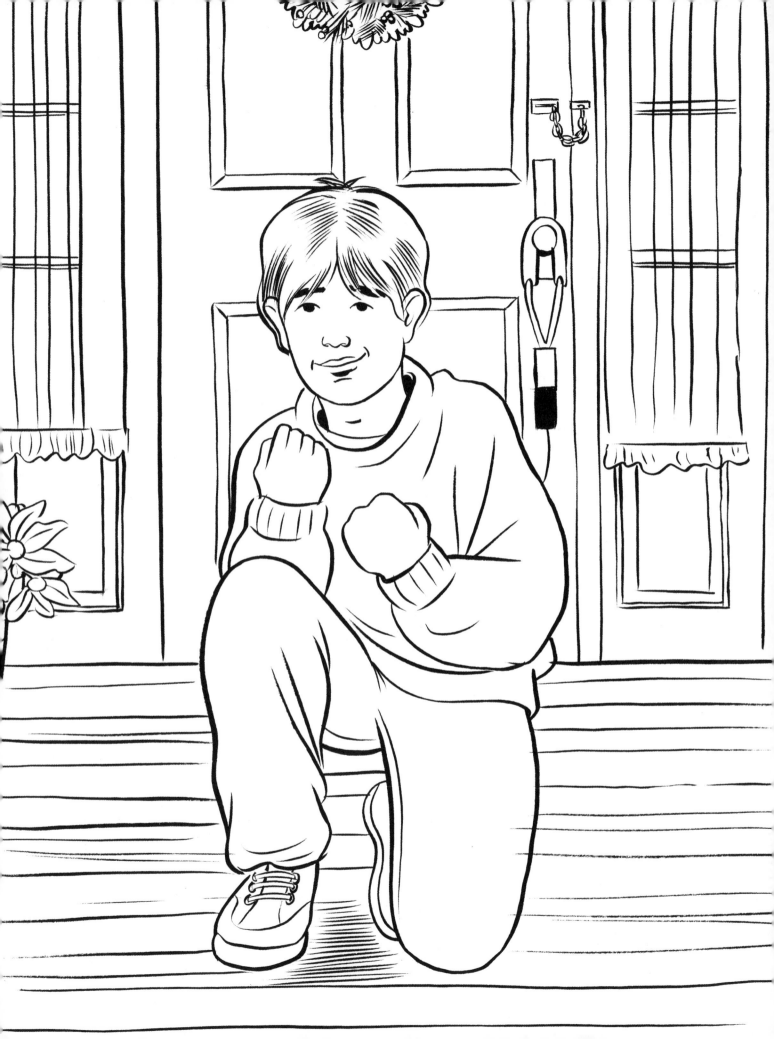

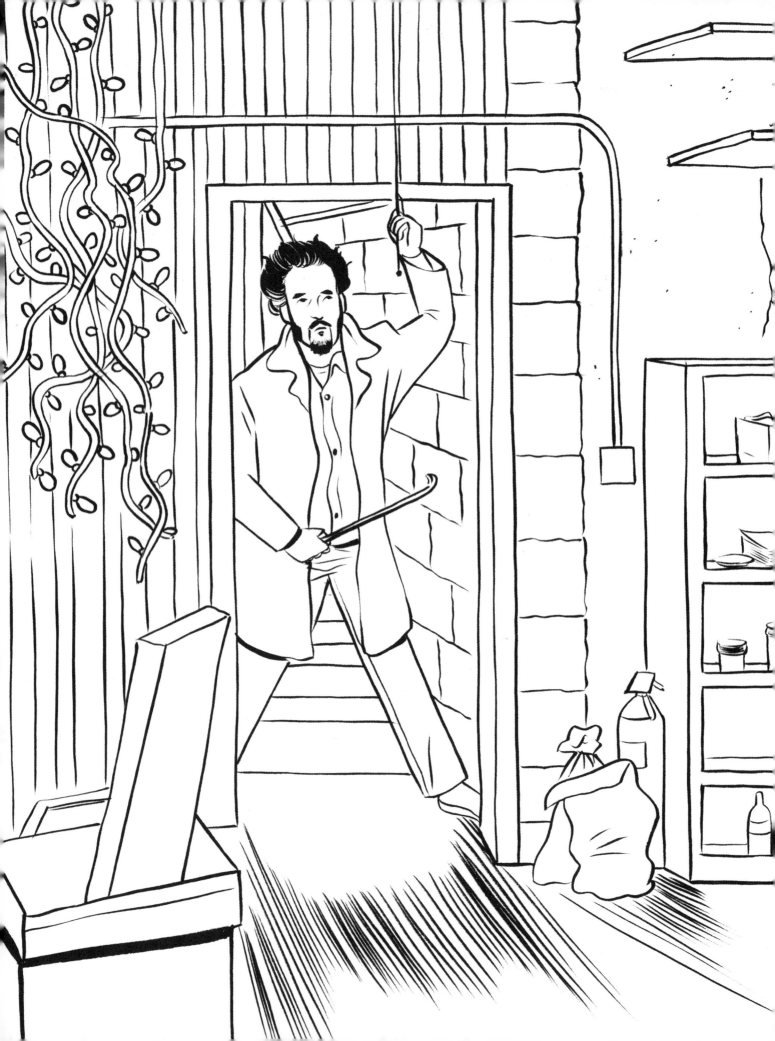

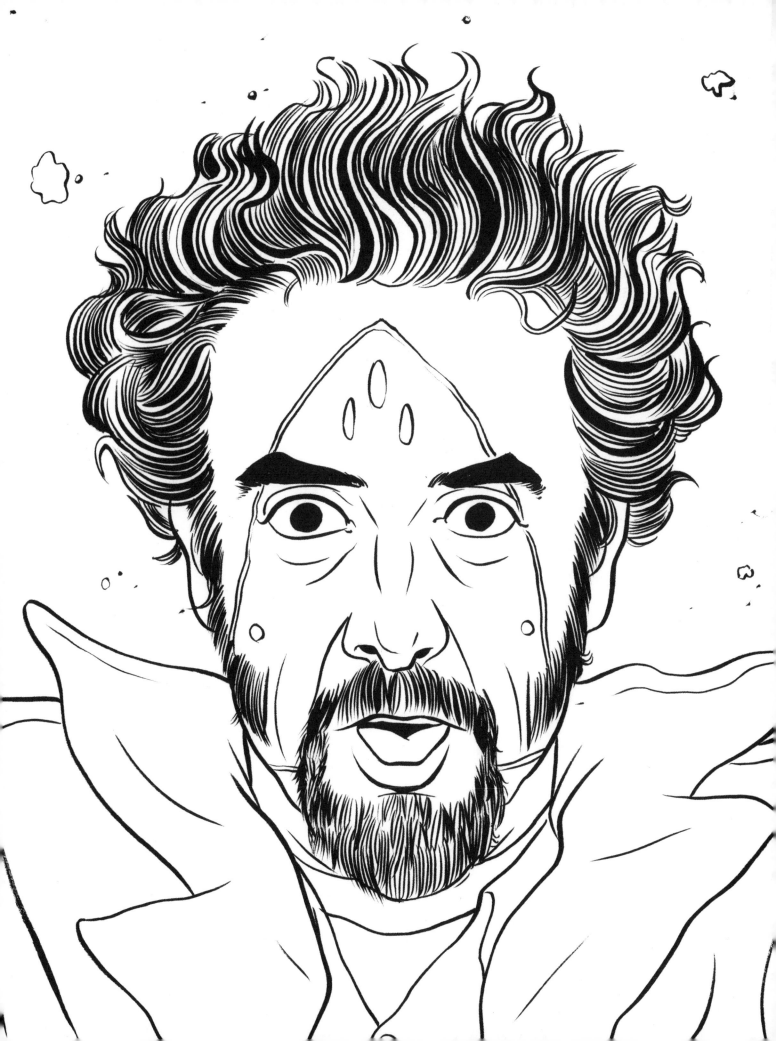

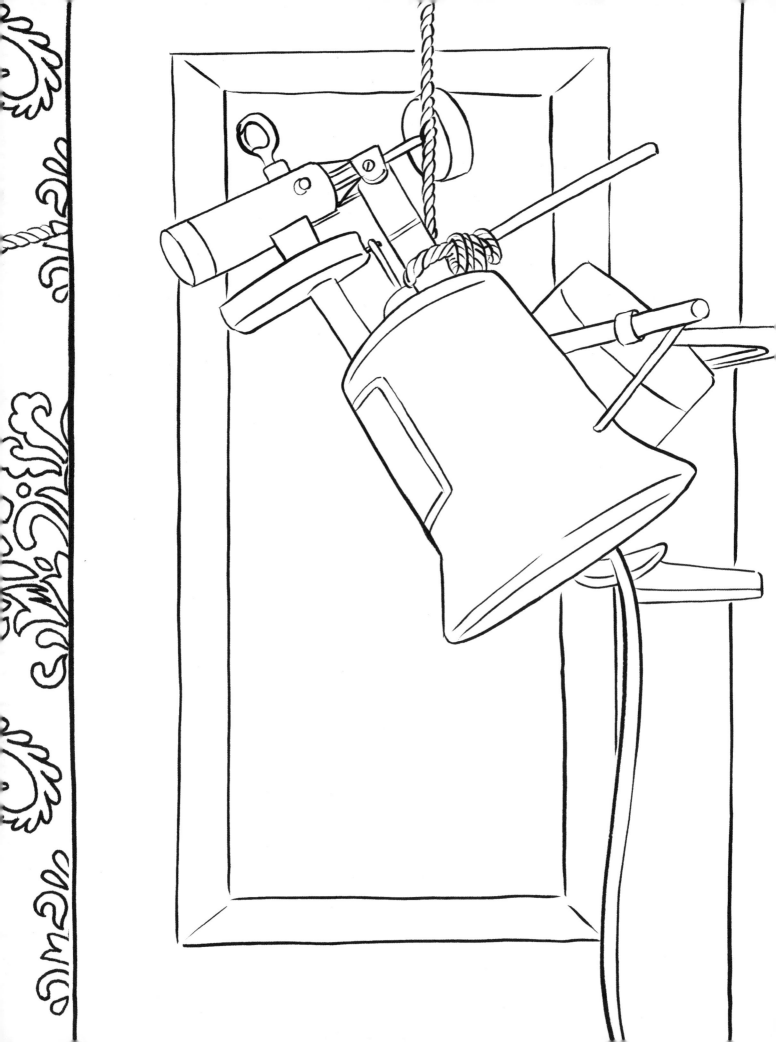

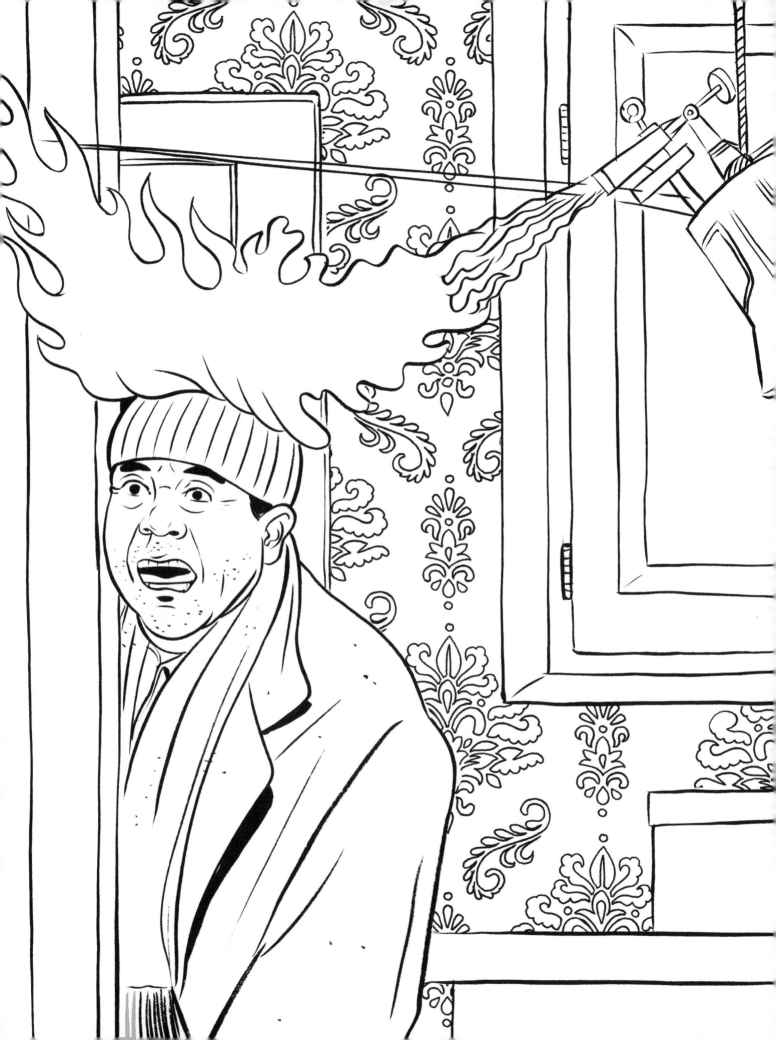

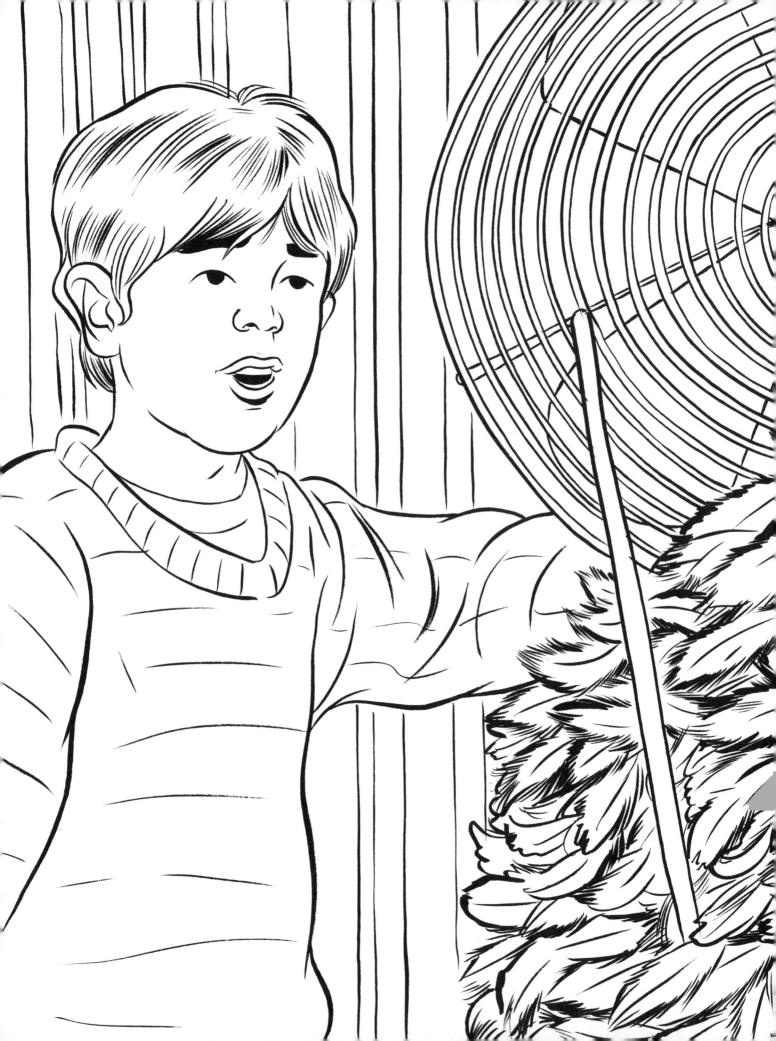

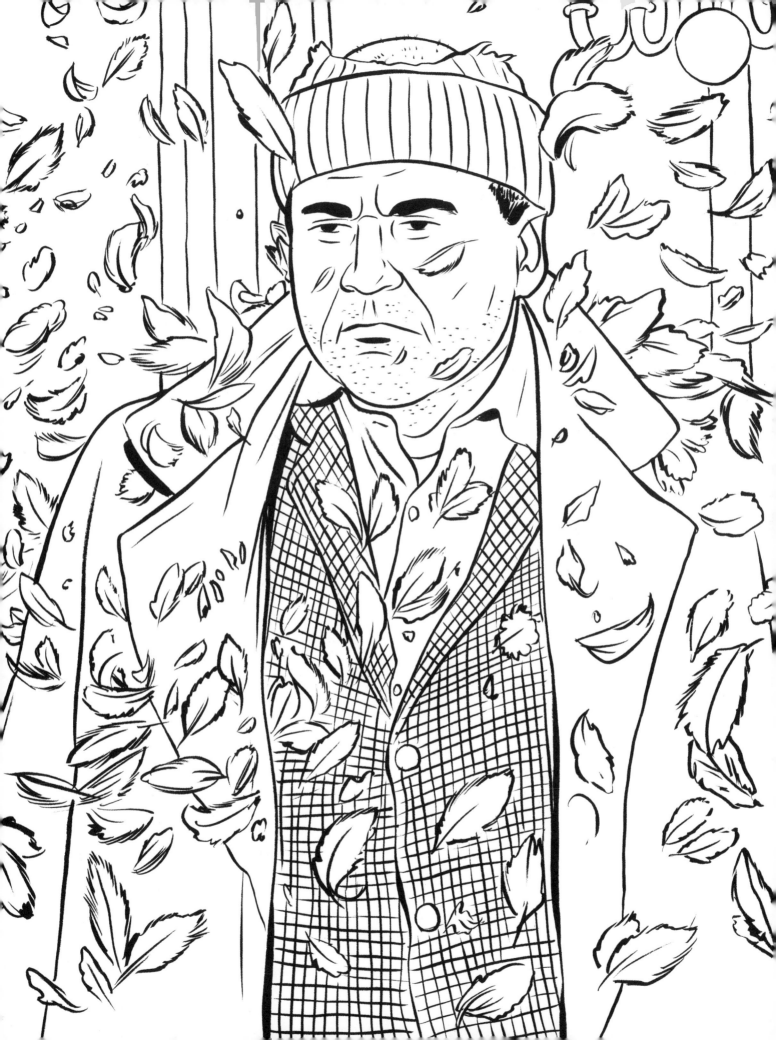

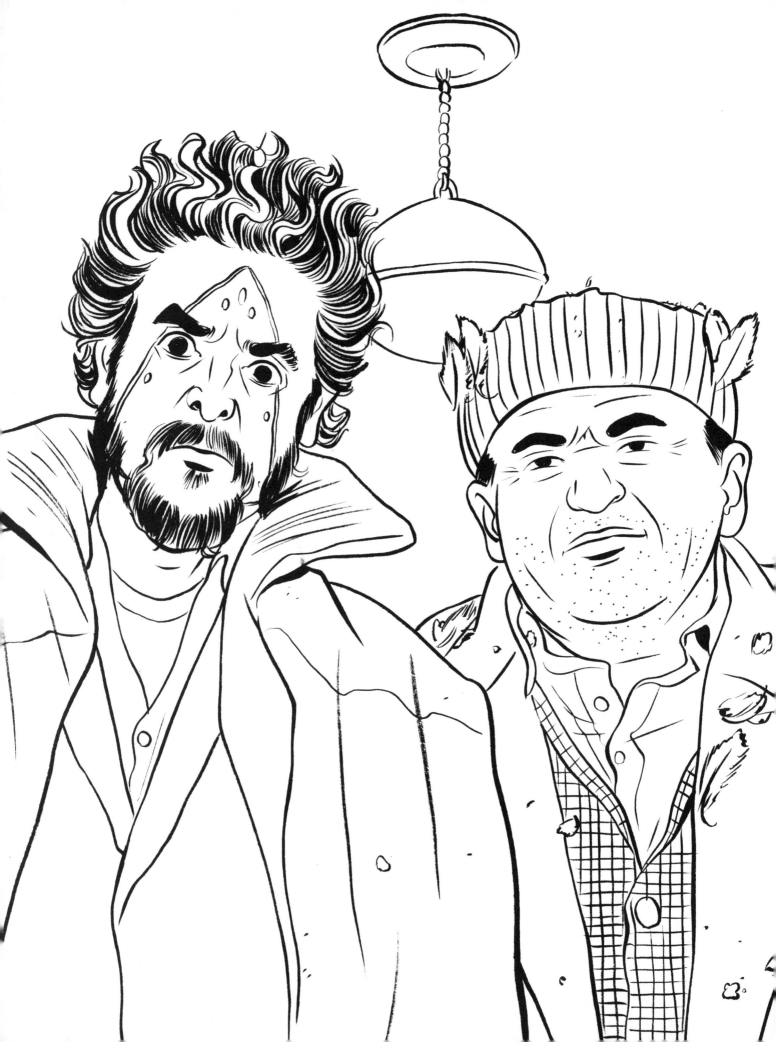

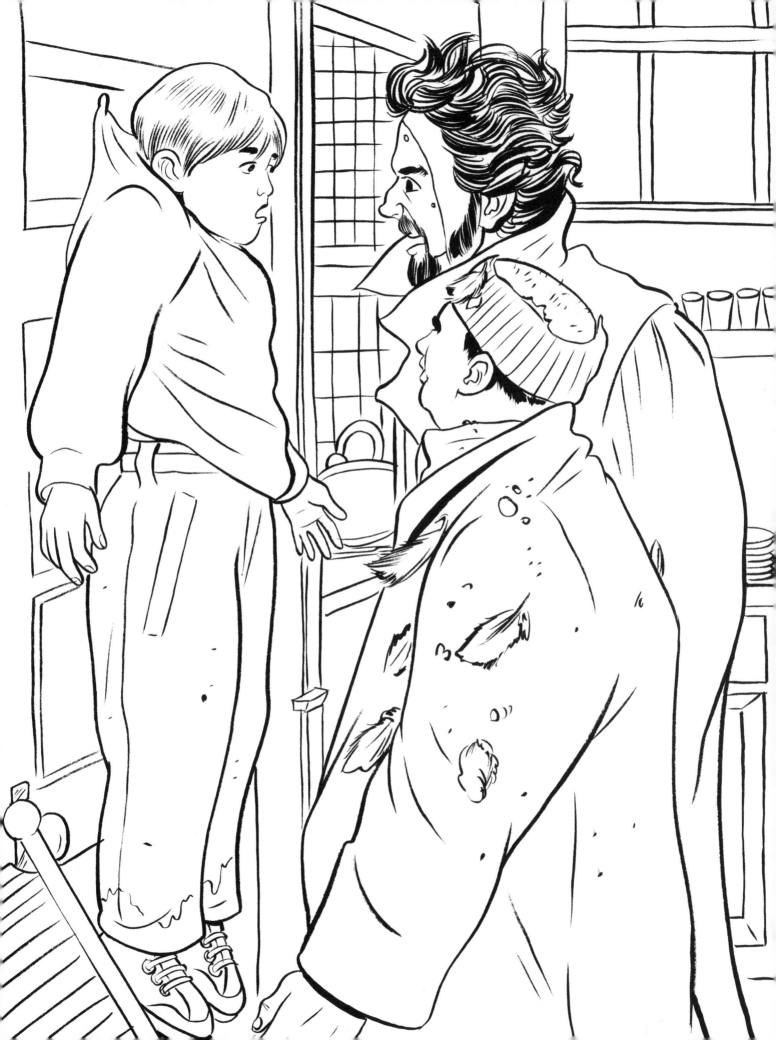

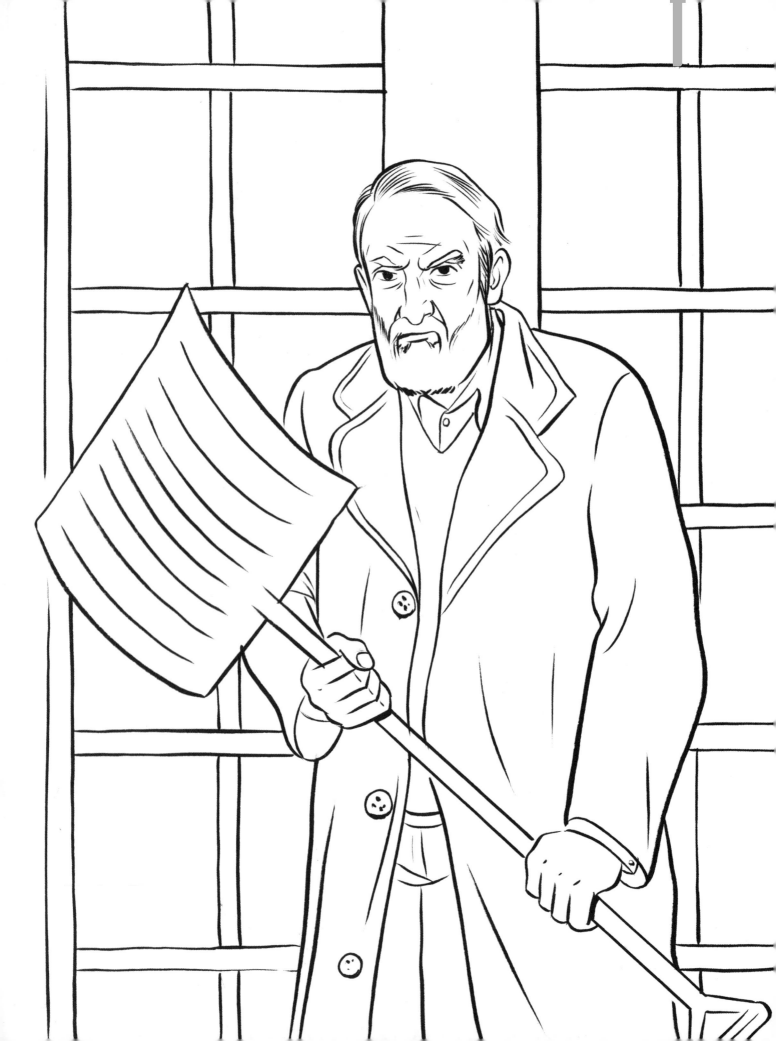

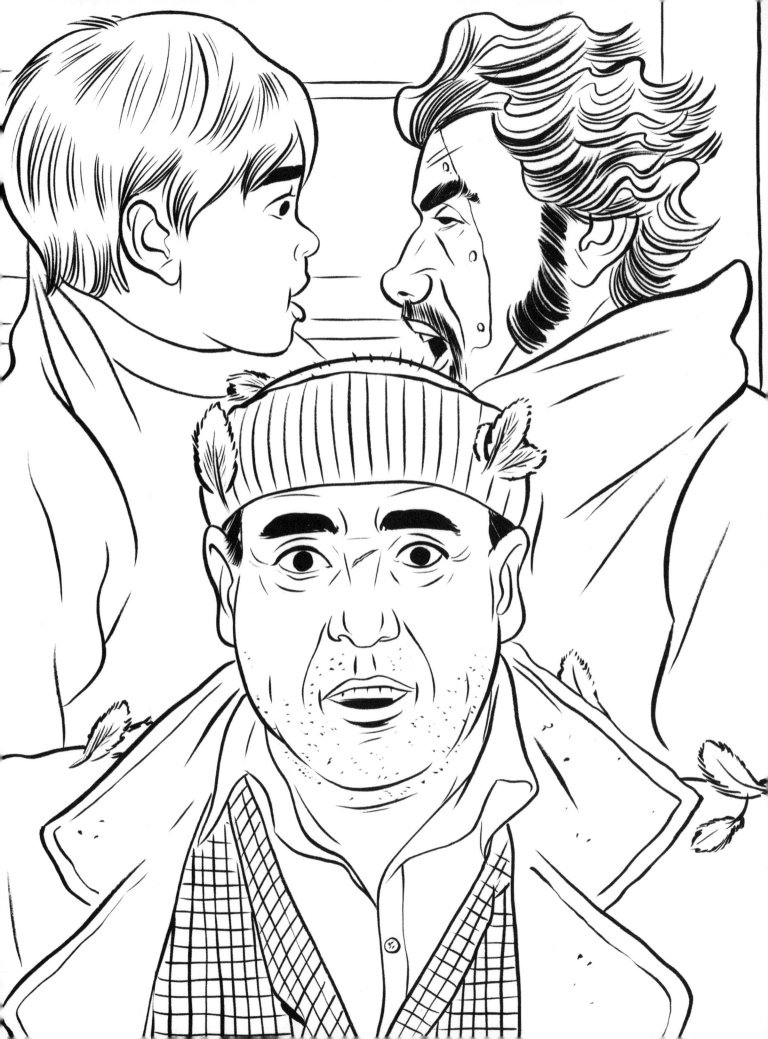

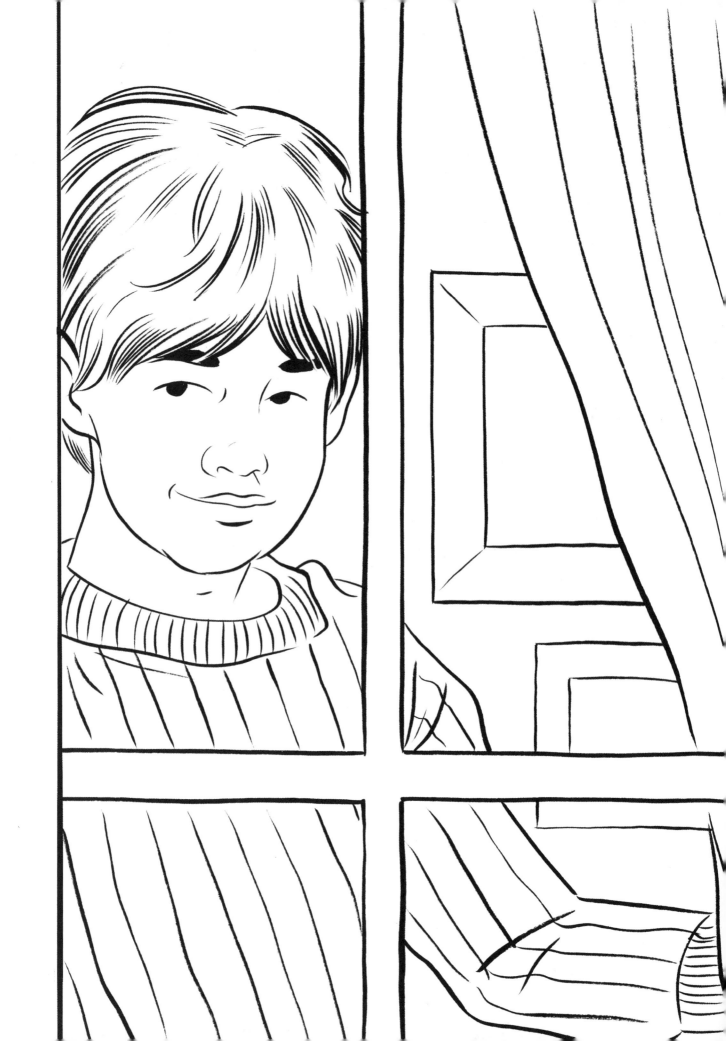

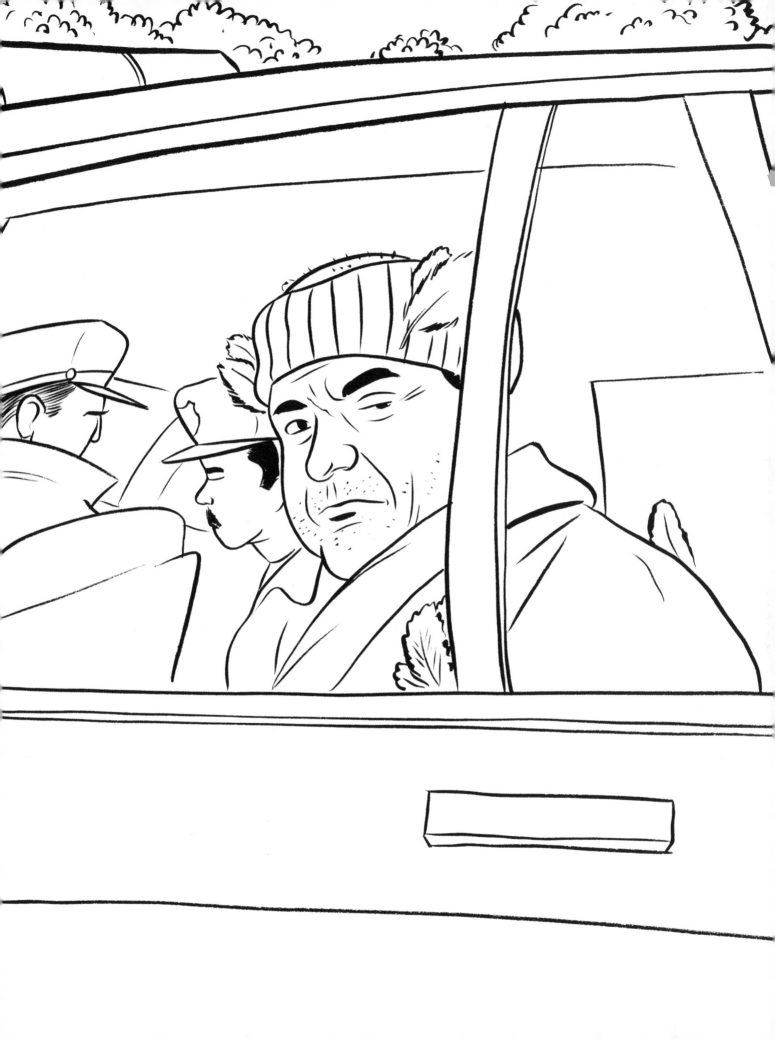

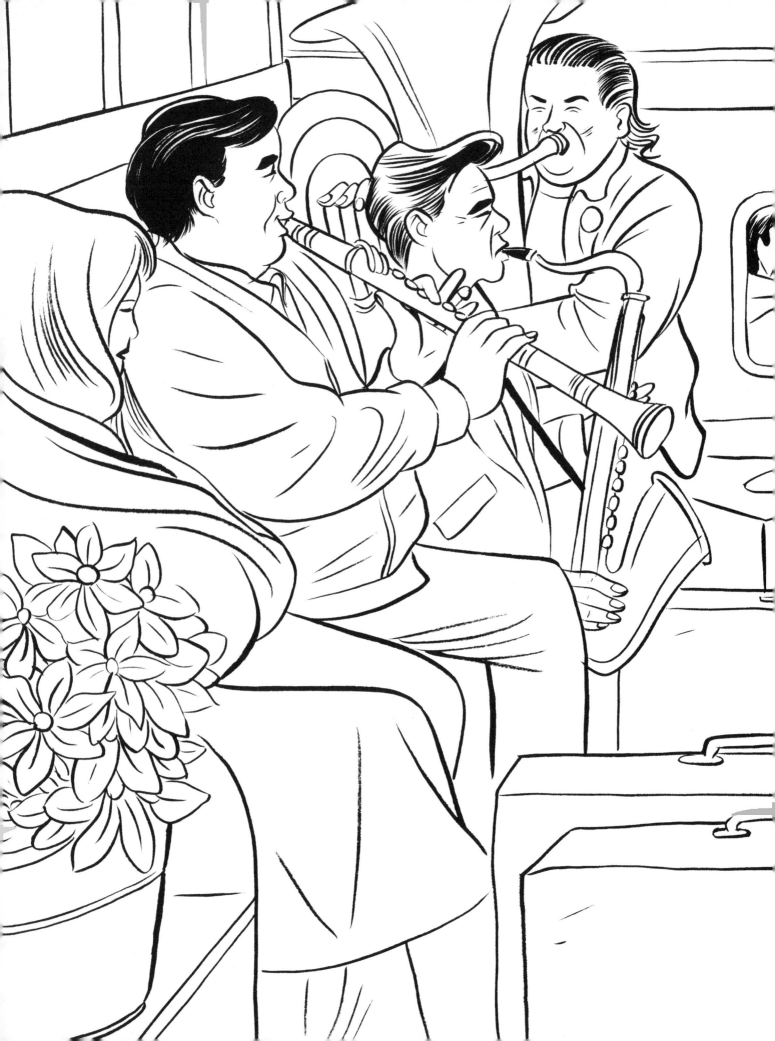

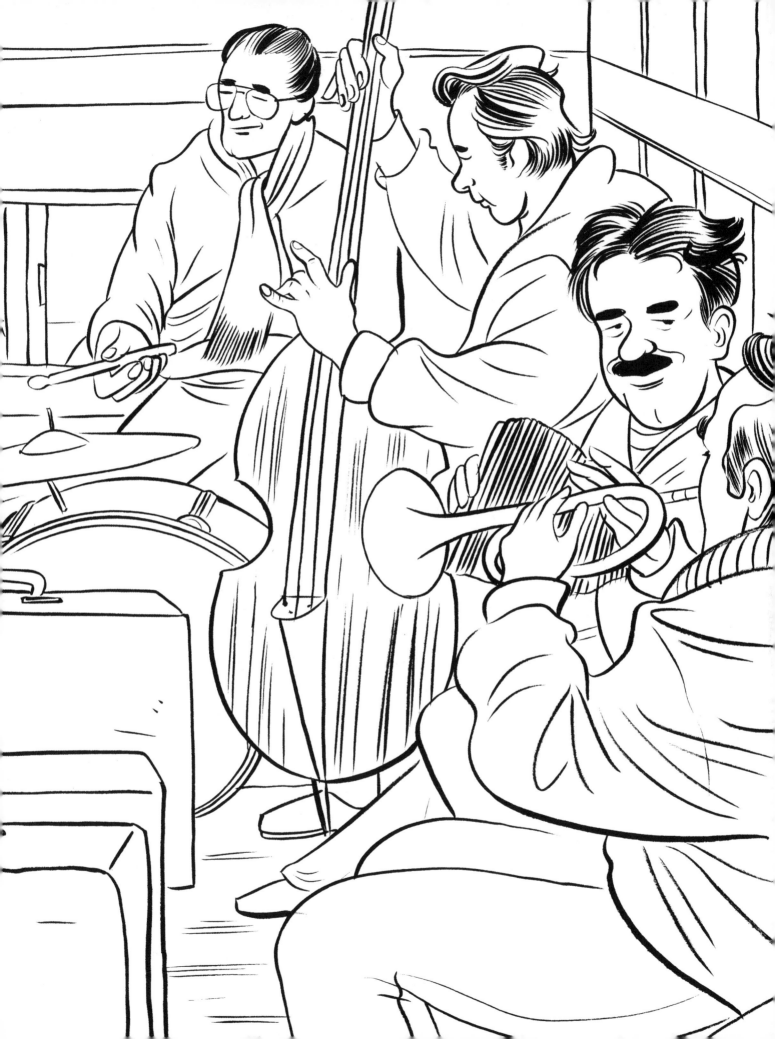

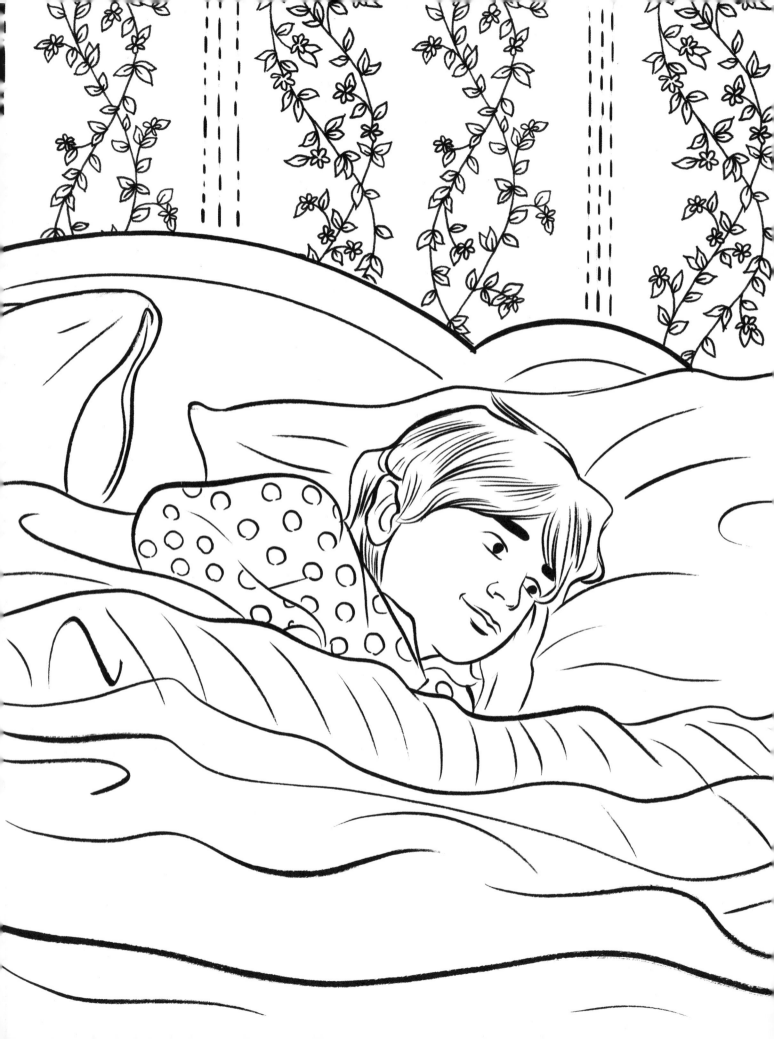

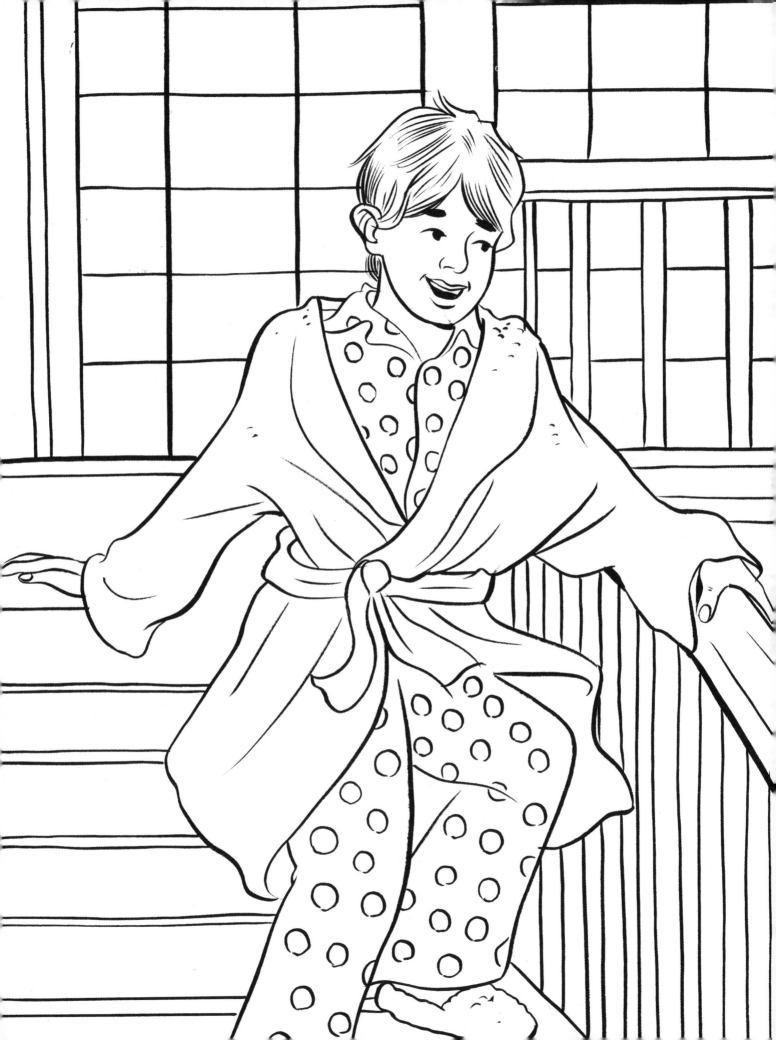

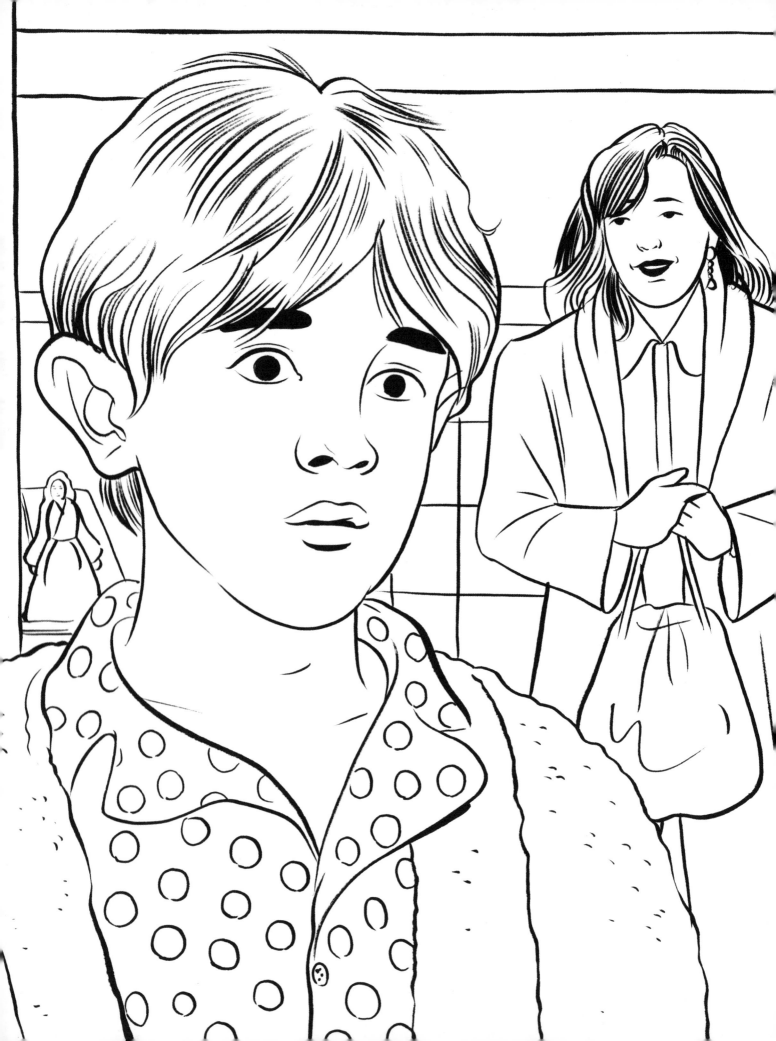

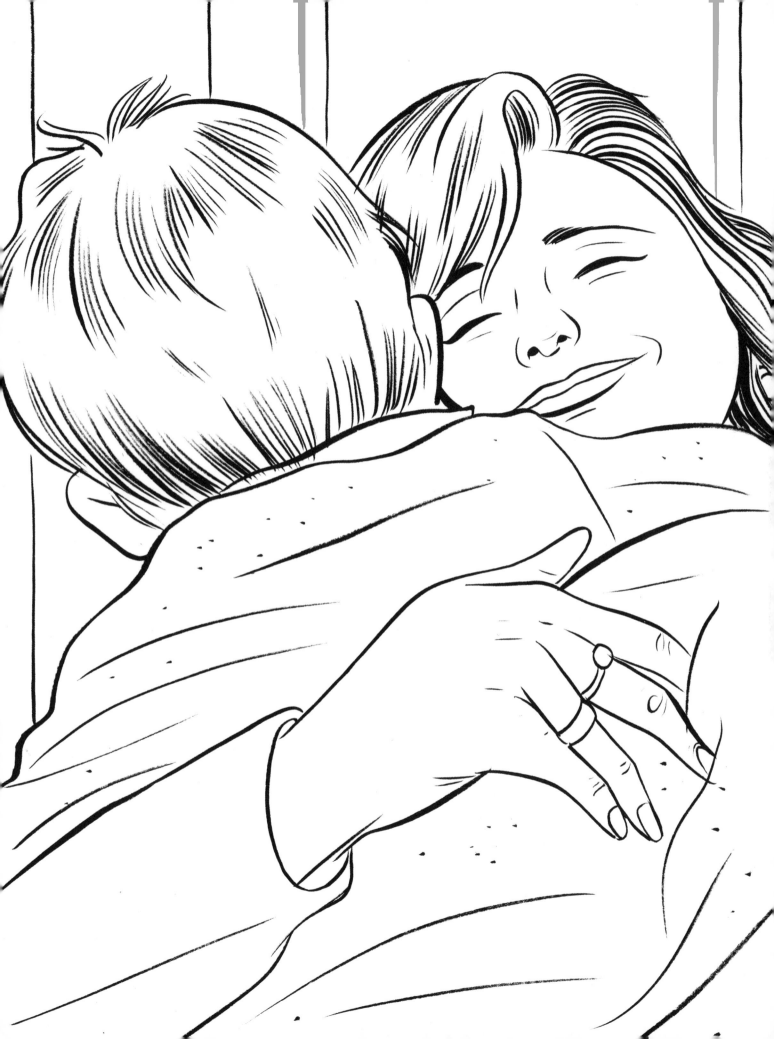

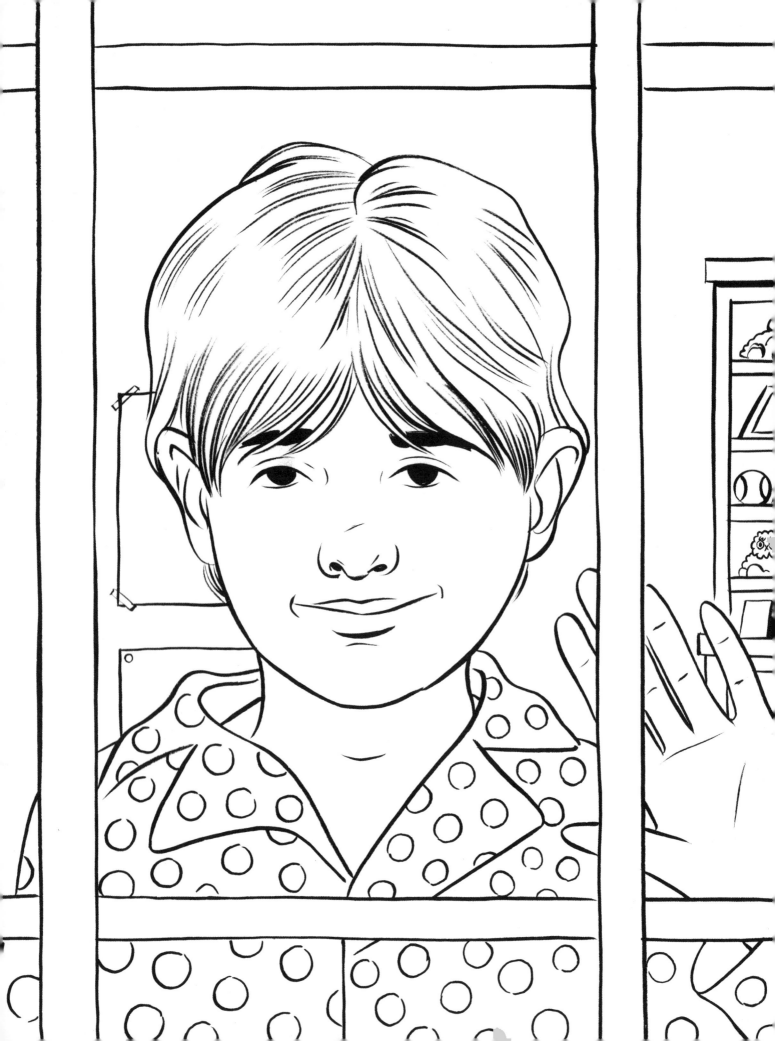

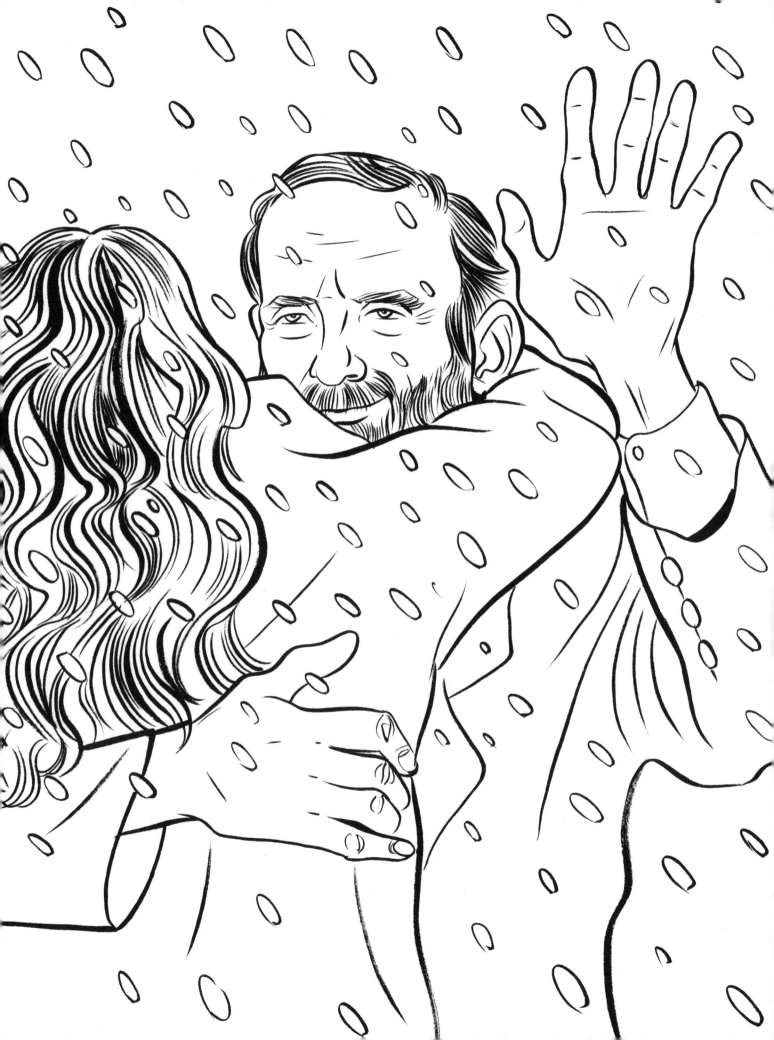

Published in 2016 by
Harper Design
An Imprint of HarperCollins*Publishers*
195 Broadway
New York, NY 10007
Tel: (212) 207-7000
Fax: (855) 746-6023
harperdesign@harpercollins.com
www.hc.com

Distributed throughout the world by
HarperCollins Publishers
195 Broadway
New York, NY 10007

ISBN 978-0-06-249301-9

Manufactured in Vietnam

Fourth Printing, 2023